PROHIBITION in
KANSAS CITY
MISSOURI

PROHIBITION in KANSAS CITY MISSOURI

HIGHBALLS, SPOONERS & CROOKED DICE

JOHN SIMONSON

AMERICAN PALATE

Published by American Palate
A Division of The History Press
Charleston, SC
www.historypress.net

Copyright © 2018 by John Simonson
All rights reserved

First published 2018

Manufactured in the United States

ISBN 9781467138710

Library of Congress Control Number: 2017960345

Notice: The information in this book is true and complete to the best of our knowledge. It is offered without guarantee on the part of the author or The History Press. The author and The History Press disclaim all liability in connection with the use of this book.

All rights reserved. No part of this book may be reproduced or transmitted in any form whatsoever without prior written permission from the publisher except in the case of brief quotations embodied in critical articles and reviews.

For Susan

Contents

Preface … 11
Acknowledgements … 15

1. John Barleycorn Is (Not Quite) Dead … 17

2. King of the Bootleggers … 20
 816 East Armour Boulevard … 21
 2101 Central Avenue … 23
 520 Gillis Street … 25
 1321 Virginia Avenue … 28
 1205 Independence Avenue … 30
 2932 Fairmount Avenue … 32
 1141 East Fifth Street … 35
 823 Walnut Street … 36
 1913 Broadway … 38
 803 Walnut Street … 40

3. Four Highballs … 43
 1131 East Thirty-First Street … 44
 423 Southwest Boulevard … 46
 818 Baltimore Avenue … 48
 3403 West Fifty-Third Street … 50
 618 West Forty-Eighth Street … 53

Contents

927 McGee Street	55
6151 Paseo Boulevard	56
4. Greed, Vice and Sensuality	59
205 East Ninth Street	60
104 West Ninth Street	63
500 Walnut Street	66
525 Gillis Street	68
122 West Eighteenth Street	70
3504 Troost Avenue	72
523 West Twelfth Street	74
30 West Pershing Road	76
416 East Fifth Street	78
5907 Main Street	80
429 Walnut Street	82
1516 East Eighteenth Street	84
5. Yokels and High Rollers	87
2020 Main Street	88
1922 Main Street	90
1900 Main Street	92
1114 Baltimore Avenue	93
100 West Twelfth Street	96
1210 Baltimore Avenue	98
1228 Baltimore Avenue	101
6. Let Us Dare to Do Our Duty	104
207 Southwest Boulevard	105
315 Cherry Street	106
1519 Main Street	108
1311 East Thirteenth Street	111
103 West Nineteenth Street	114
1016 West Twenty-Fourth Street	117
1809 Grand Boulevard	119
1608 Main Street	121
406 East Eighteenth Street	123
2860 Southwest Boulevard	126
Third and Locust Streets	128

Contents

7. Something More Than Beer	131
109 West Eighteenth Street	132
1717 West Ninth Street	133
7321 East Fifteenth Street	136
1822 Vine Street	138
1414 East Fifteenth Street	140
1706 Baltimore Avenue	142
8. Wet and Wicked	144
A Few Postscripts	145
Selected Bibliography	151
Index	153
About the Author	157

Preface

This is not a comprehensive history of Prohibition. It's not a close examination of its unintended consequence, organized crime, or of its marvelous soundtrack, jazz. It won't add much to the biography of Thomas J. Pendergast, the political boss in power at the time. Other authors have covered that territory.

Rather, this is my attempt to channel ghosts from Kansas City's version of Prohibition, to exhume forgotten stories by revisiting buildings and structures they haunt, places that have survived the nine decades separating then from now.

Prohibition lasted thirteen years, from 1920 to 1933, years when the chamber of commerce promoted the city as the "Heart of America," a good place to do business. It was a period of growth in population, culture, industry and construction. By 1929, the city had sixty buildings over ten stories tall, and as the country's nineteenth-largest city, it had the eighth-tallest skyline.

But alcohol and assorted other vices had been longtime ingredients of Kansas City culture, helping nineteenth-century saloonkeepers like Jim Pendergast and his younger brother Tom cultivate boss-style politics. One Republican rival even imagined Prohibition would end Tom's political career. "The heart of the old North Side political machine was removed with the closing of saloons," he declared in 1920, a bit prematurely.

Kansas Citians still indulge in gauzy-glamorous nostalgia for Prohibition, probably a blend of 1930s Hollywood gangster movies, twenty-first century

Preface

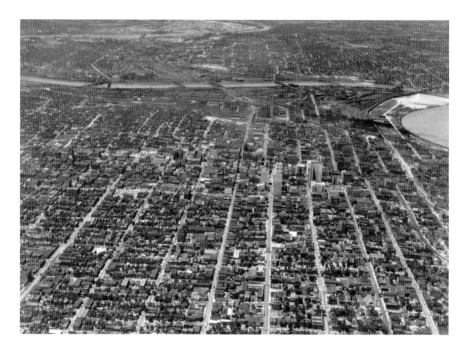

Downtown, looking west, 1930. *Missouri Valley Special Collections, Kansas City Public Library, Kansas City, Missouri.*

cocktail culture and some sense of what the Pendergast era was all about. Stanley Crouch, in his biography of Charlie Parker, summarized it well:

> In the empire of Tom Pendergast, there was wall-to-wall sin and swing, wall-to-wall exotic entertainment and gambling. People came to guzzle the blues away, to dance the night long, to take the risk of leaving in a barrel as they laid bet after bet; and, as ever, there were those who came to involve themselves in the mercantile eroticism of the high to low courtesans.

Much of our nostalgia actually dates to after Prohibition was repealed. "Paris of the Plains" was a late-1930s nickname for the wide-open town visiting journalists saw: the Reno and Chesterfield clubs, Dante's Inferno, naked waitresses, open casinos. Yes, that town grew out of the speakeasy version, but today we sometimes hear Kansas City was a place where Prohibition didn't exist, where no citizen ever was convicted of violating the Volstead Act. It's just not true.

Author Daniel Okrent's comprehensive, four-hundred-page history of Prohibition barely mentions Kansas City, although he does present a familiar

Preface

reality of many cities, including Kansas City. "Political corruption had been baked into the system almost from the beginning," he wrote. "A man who delivered jobs, projects, and pork to his district could be forgiven much."

Much of this book reflects press coverage of the era, primarily in Kansas City daily newspapers but also numerous publications nationwide, as well as some of those excellent history books.

It's a look at *what* we Kansas Citians drank, *how* and *where* we drank it, *why* moralists warned us about it, *who* flaunted the laws and tried (sometimes) to enforce them, *when* the Heart of America was about to become the Paris of the Plains.

Acknowledgements

As always, I owe much to the reference department (Bill Osment) and Missouri Valley Special Collections (Jeremy Drouin and staff) at the Kansas City Public Library. Lucinda Adams and crew at the Kansas City Research Center of the State Historical Society of Missouri were also quite helpful.

Andy Rieger, Tom Barelli and Bob Carlston provided information on their Prohibition-era families. Ryan Maybee of J. Rieger & Company and Tony Botello of tonyskansascity.com lent help and support. I'm indebted to many Kansas City journalists of the past, too many to list, but notably Landon Laird, A.B. MacDonald and John Cameron Swayze.

I thank my History Press editor, Chad Rhoad. And I'm forever grateful for the encouragement and patience of my friends and family.

1

JOHN BARLEYCORN IS (NOT QUITE) DEAD

The *Times* story opened like an obituary. "John Barleycorn, a resident of Kansas City and most of the world, died at midnight last night," it began, using the English folk song's personification of alcohol. He was "probably the oldest resident of the city at the time of his death."

It was the morning of January 17, 1920, the first day under the Volstead Act—the working part of the Eighteenth Amendment—which made it illegal to "manufacture, sell, barter, transport, import, export, deliver, furnish or possess any intoxicating liquor except as authorized."

A lesser prohibition had been in place since the previous summer. In 1918, President Woodrow Wilson signed an agriculture bill that included a wartime prohibition amendment outlawing the sale and importation of intoxicating liquors until after the army had demobilized from the world war. Just before the bill became law on July 1, 1919, Kansas City had nearly 450 saloons, down from 1917, when a local pastor wondered aloud, "Can Kansas City be a Christian city with six hundred saloons running wide open, paupering our homes, killing our babies, wrecking our fathers and husbands and brothers?" Further, the city was riddled with places "in which vice flourishes," he said. "It is a wonder to me that with our children beset with such temptations so many of them issue into noble men and women."

With the war's end, the country was entering a decade of loosening morals, of new freedoms for women, including the right to vote, and of temptations associated with illegal alcohol. "A whole generation had been infected by the eat-drink-and-be-merry-for-tomorrow-we-die spirit which accompanied

the departure of the soldiers to the training camps and the fighting front," one journalist later recalled. "It was impossible for this generation to return unchanged when the ordeal was over."

As author Eric Burns described, it would become "a time more desperate than carefree, more unjust than equitable, more punishing than leisurely, more revolutionary than placid, more worrisome than confident, more threatening than assured."

On June 30, 1919, large Kansas City hotels nevertheless greeted wartime prohibition with hats and horns and liquor parties. People flocked to saloons, carrying baskets or pulling little wagons to lay in last-minute supplies. Stores advertised suitcases: "Each case will hold eighteen quarts." Late that night, it was almost impossible to get near a bar. After closing time, people wandered streets carrying bottles.

But real enforcement of wartime prohibition didn't get serious until after Congress passed the Volstead Act that October. Police then began raiding and closing notorious places. Still, by January 16, 1920, the last day before full-blown Prohibition, 160 saloons remained open. Perhaps not everyone believed alcohol would truly disappear. That night, there was less last-minute excitement than the previous summer and "no celebration worth the name," according to the next day's *Times*. "Saloons were very nearly deserted." The *Times* and its evening version, the *Star*, had long been and would remain staunchly supportive of Prohibition. A rival newspaper had a different take. "Hotel cafés and cabarets glowed with New Year's vigor last night," the *Journal* reported, continuing:

> *Every bright-light place was packed. Some brought "it" with them and others evidently got "it" from other sources. All seemed to have "it." Crowds wended their way up and down Twelfth street, tramping from one cabaret or café to another. The celebration scarcely was reaching its height when the clock tolled the fatal 12. But by that time few seemed to care about the clock. Many even had forgotten what the hour of 12 meant.*

Elsewhere in town, members of the Woman's Christian Temperance Union celebrated for a different reason: the partial realization of their longtime goal to wipe out liquor consumption. "Petty crimes, brawls, and wife beating have passed, largely, with the coming of Prohibition," said one. "We will not be satisfied until we have changed not only the laws, but the attitude of the world toward liquor."

Ultimately, they would fail. And it wouldn't take long to realize that not even local attitudes would change. Just four months later, a St. Louis reporter came to town and declared Kansas City "the last wide-open town."

"If you want to see John Barleycorn dying like a gladiator buy a ticket for Kansas City," he wrote. "The old boy, though groggy and bleeding, still hangs to the ropes and refuses to take the count."

2
King of the Bootleggers

In the 1920s, your booze had one of several possible origins.

You might have owned it when Prohibition started, in which case you needed proof of purchase date. You might have obtained a prescription for "medicinal whiskey" from your doctor, the only legal way to buy liquor. It could had been sold to you—and probably homemade—in violation of the Volstead Act.

A doctor analyzing available alcohol for the American Pharmaceutical Association divided it into three classes: "Properly made whisky and brandy, synthetic liquors, and moonshine or home-brew," which has been "fermented and distilled surreptitiously." Only the first class could be considered safe to drink, he said. And you never knew for sure what you were getting.

Throughout Prohibition, the quality of booze varied in Kansas City, from vintage bonded liquors smuggled in from Canada or Mexico to vile locally made poison that was labeled, priced and sold as "real stuff" and much in between.

It probably came from your favorite local bootlegger, a man you trusted as a source of "bottled in bond," supposedly brought in by Pullman porters on the night train from New Orleans. Chances were excellent that he was actually selling his own "bottled in barn" blend, possibly in competition with other bootleggers, adding a touch of danger and intrigue. As author Paul Dickson noted:

> *Prohibition was responsible for a number of unintended consequences, including acting as the catalyst for the rise of organized crime and a culture in which bootleggers and rumrunners were often more admired than reviled. The most successful bootleggers—as represented by F. Scott Fitzgerald's fictional Jay Gatsby—accumulated great wealth, which granted these men entrée into high society.*

In 1926, the chamber of commerce solicited reviews of Kansas City from recent visitors and conventioneers. Comments praised the city's business climate, its parks and boulevards and its courteous citizens. Some mentioned bad traffic, uncomfortable weather or the foul odor from the stockyards. A couple ventured into shady territory.

"You are badly in need of good beer," said a man from Indiana. A visitor from North Carolina wrote, "Your liquor is high and of poor quality."

816 East Armour Boulevard

It's one of those brick-and-limestone residences common to the North Hyde Park neighborhood, this one three stories facing Armour, with a basement garage and driveway entrance on Campbell. In an era when garages typically were detached from the home, this one promised convenience and security. A fine place, say, to squirrel away your liquor.

Anticipating wartime prohibition taking effect on July 1, 1919, many liquor suppliers, saloonkeepers and individuals moved stocks of beer, wine and distilled spirits into private storage. When the Volstead Act became law the following January, all private stocks were subject to strict rules. Liquor owned as of June 30, 1919, had to be stored in the owner's residence and could be served to guests only. In residence hotels, it could be served in the hotel dining rooms. Club members had to reside in the club to keep liquor there. Owners were required to file a complete inventory with the Bureau of Internal Revenue.

In November 1919, 816 Armour was the home of Samuel E. Sexton, a builder. He and his partner, George Hucke, had constructed several substantial homes as well as the Heim Brewery and its Electric Park in the East Bottoms and the Hotel Sexton downtown.

The Sexton, near Twelfth and Baltimore, was a favorite of traveling cattlemen doing stockyard business, and it featured a popular bar operated

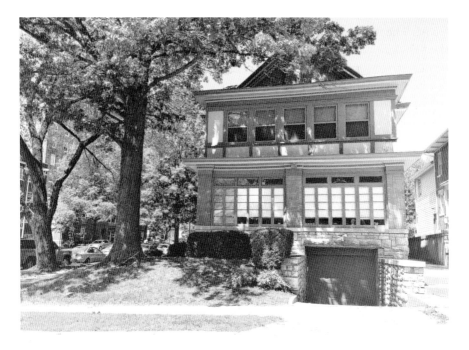

The Sexton family lived at 816 East Armour Boulevard. *Author photo.*

by Samuel Sexton. That summer, as wartime prohibition went into effect, Sexton shut the bar and remade it as a restaurant. He packed up the remnants of his liquor stock and trucked it to his home on Armour, stashing it in a basement storeroom off the garage.

The night after Thanksgiving, the Sexton family had just sat down to dinner when the doorbell rang. Half a dozen men with handguns burst into the dining room. All but one hid their faces behind overcoat collars. The leader wore a mask and ordered everyone upstairs. He grabbed Sexton and demanded to know where the booze was. Sexton led him to the basement storeroom.

A truck was backed down the driveway and into the garage. Soon the thugs were driving off with high-octane booty—bottles of wine and cordials, ten cases of gin and fifteen jugs, plus three barrels of whiskey valued at $5,500. From what the robbers said, Sexton suspected at least one knew him, but he couldn't be sure.

The private stocks of wealthy citizens soon became objects of desire. In the summer of 1920, W.R. Pickering of the Pickering Lumber Company lost a dozen cases of English whisky to three armed men at his Hyde Park

home. The robbers were later caught, and some liquor was recovered. It was the first liquor robbery to be prosecuted and established that it had a market value—and therefore theft of it constituted robbery—even though it could not be sold legally.

2101 Central Avenue

The brick building with the scalloped cornice on the southeast corner of Twenty-First and Central is the former home of the T.J. Pendergast Wholesale Liquor Company. In December 1920, the company filed an appeal in federal court to regain its license to handle whiskey for its few legal purposes. Since 1911, the company had operated at 525 Delaware with a warehouse at 201 Grand. Both were near Boss Tom's other North Side interests—the Jefferson Hotel and the Jackson Democratic Club, then inside the hotel. The hotel closed in summer 1920, the club moved to offices in the Gumbel Building and the liquor company settled into this new location on Central.

Wholesale liquor companies had once been plentiful in Kansas City. Many operated out of the North Side along Wyandotte and Delaware Streets south of Fifth. There were so many wholesalers because of the numerous saloons—six hundred or more, almost one on every corner in business sections of town. Wholesalers were middlemen between distillers and saloons, although some sold spirits bottled under their own brand names. J. Rieger & Company, down on Genessee Street opposite the stockyards, commissioned whiskey from a distillery in Louisville, Kentucky, and bottled it here under its Monogram label. Rieger was primarily a national mail-order business, and its products were rare in local saloons.

Prohibition meant the end of the line for J. Rieger and most wholesalers. Boss Tom's business reinvented itself as the T.J. Pendergast Distributing Company—a dealer in soft drinks, legal trace-alcohol "near-beer" and products like Blue Ribbon Malt Syrup, which had value mainly to folks who made illegal home-brew. Atlas Brew, a Chicago product, was in the Pendergast line. By 1932, it was somehow the only near-beer sold at Muehlebach Field (the Muehlebach Brewery quit business in 1929) or any other amusement venue in town.

The day-to-day manager of the T.J. Pendergast Distributing Company was the Boss's longtime friend Phil McCrory. McCrory's early reputation

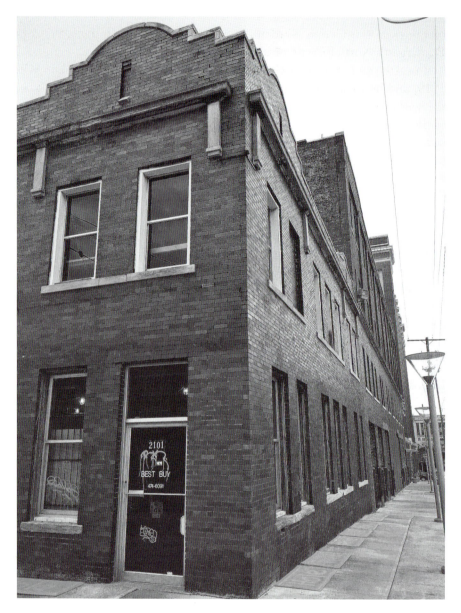

The former T.J. Pendergast Wholesale Liquor Company, 2101 Central Avenue. *Author photo.*

was as a gambler and turn-of-the-century saloonkeeper who once shot a man dead over a woman who ran a brothel. In 1928, McCrory became the first operator of the Riverside Park racetrack near Parkville, another Pendergast operation. The next year, he helped finance a short-lived nightclub north

of the river, the Cuban Gardens, owned by Johnny Lazia, racketeer and Pendergast's North Side political strongman.

Boss Tom was said to have made a half a million dollars selling liquor in 1919, and he took a hit from Prohibition. First he tried and failed to have the Volstead Act declared unconstitutional. It's been said the company then decided to go straight, storing its booze supply in government warehouses and dealing only in legal beverages. Except there was that matter of the license to sell legal alcohol.

The December 1920 appeal in federal court was necessary because the license had been revoked two weeks earlier. The T.J. Pendergast Wholesale Liquor Company had sold nine hundred gallons of whiskey on forged permits. The appeal failed.

520 GILLIS STREET

Glass blocks and Royals regalia mark the entrance to a former grocery on Gillis, in the heart of the North Side neighborhood once filled with Sicilian immigrants and their first-generation offspring. In January 1922, a police raiding squad stopped here and confronted the proprietor.

"I smell a still," said the police sergeant.

"I don't know," said the grocer.

"I'm going to find it."

"Maybe so."

Hours later, after chopping through two brick walls into a subbasement too cramped to stand up in, the cops discovered the source of the smell: several barrels of corn mash and three fifty-gallon stills.

"I don't know," said the grocer.

During Prohibition, stills of many sizes were discovered all over Kansas City, commonly from 15 to 250 gallons. The capacity represented the potential output per day. In 1928, a 2,000-gallon still, maybe the largest ever, was found on the second floor at Fifth and Wyandotte. Often great effort was made to conceal an operating still. One was found in a vented underground room beneath a vegetable garden being watered by the mother of nine children. Subterranean stills were hidden in hand-dug caverns below chicken houses or pigeon coops, even in an abandoned well with a large anteroom. Others operated on islands in the Missouri River or deep in the woods along the East Bottoms, guarded by snipers in trees.

A moonshine still was found at 520 Gillis Street. *Author photo.*

Sometimes neighbors complained of suspicious activity at all hours of the night, people coming and going, carrying packages. Police would follow the familiar pungent odor. Warm window glass could indicate an operating still inside. Steam rising from rooftop pipes on apparently vacant houses raised suspicion.

The product of these stills was corn liquor, sometimes referred to as corn whiskey (or "white mule"), but it could be artificially colored and flavored to simulate various spirits. Writing in the *Post* in 1921, the city's chemist explained the distillation process:

> *Before the present prohibition laws went into effect, whisky was the distilled spirit from the properly prepared and fermented mash of malted grain, or of grain the starch of which had been converted into sugar by the action of malt. It was stored in wooden containers for not less than four years and contained approximately 45 percent by volume of ethyl alcohol. Whisky, when freshly made, is perfectly colorless, the color and mellowness of flavor being imparted to it by aging and by storage in the wooden casks.*

The chemist was writing to warn the public about poison liquor, the product of careless distilling. The first and last parts of the distilled spirits should be discarded, he said, to remove the harmful substances. As bootleggers cared primarily about getting maximum liquor out of minimal ingredients in a short amount of time, they often used the entire batch, with virtually no aging. And they sometimes worked in filthy conditions, which meant contaminated liquor. Reports of worm-infested mash or mice and roaches floating in open containers sometimes appeared.

The North Side neighborhood was especially prolific in illegal booze production. Bootleggers sometimes enlisted Italian immigrants who spoke little or no English to run stills. A still could be the best option for a poor widow or a young wife whose husband was in jail, especially if she had mouths to feed. It was better than prostitution. One sixty-nine-year-old woman was caught running three stills in her apartment's attic while her seventy-three-year-old husband lay sick in bed. Another woman, in America just two months, was arrested after admitting she ran a still in her three-room apartment. The *Journal* reported she came from an Italian village to

> the great America, where she was promised great wealth and a home of her own. Her transportation she said was paid by a wealthy Italian of

A warning against the local "hooch." *From the* Kansas City Post.

Kansas City. "I operate the still to pay back the money for my passage," the woman explained in Italian. She shrugged her shoulders when asked to give the name of the wealthy Italian. "I do not remember, but he is gone out of town now."

1321 Virginia Avenue

The tidy brick warehouse just north of I-70 is larger than it looks from Virginia Avenue, stretching half a block east toward Lydia. "Hoffman Bros" is etched in framed stone over the garage, but in December 1926, this was the Big 4 Transfer and Storage Company. One day, between Christmas and New Year's, federal agents sat watching the building. That night they raided. Inside they found forty-one steel drums, each holding fifty-two gallons of industrial alcohol, and purifying equipment. They arrested a man named Joe Pasano. A longtime police character also known as "Joe Pete," Pasano had been arrested two months earlier in connection with a similar plant in the West Bottoms.

Industrial, or denatured, alcohol was essentially grain alcohol with chemicals added to make it undrinkable, an addition the federal government had required beginning in 1906 in order for manufacturers to avoid liquor taxes. The many legal uses of denatured alcohol included cleaning fluids, antifreeze, paints, perfumes and hair tonics. Converting denatured alcohol back into something drinkable became a simpler alternative to distillation for bootleggers. By 1923, some 95 percent of local liquor was said to be homemade, and according to the *Post*, most of that was from denatured alcohol.

The makers of legitimate products could buy alcohol by the railroad carload, and federal prohibition agents could not trace or control it. Bootleggers could highjack a load or collude with a legitimate manufacturer, as Frank DeMayo did. Considered Kansas City's most successful bootlegger, DeMayo was an amateur chemist. He discovered he could mix industrial alcohol with a drugstore laxative, Stanolax, bringing it to a boil, and the mineral oil would rise to the surface for skimming, bringing all but a trace of the poison with it. (He bought $200,000 worth of Stanolax.) But even a trace could be disastrous to those who drank it. Wood alcohol could cause blindness or death.

"About ninety-nine percent of the liquor consumed tonight will be hair tonic with the blindness boiled out," said the police chief on New Year's Eve 1925. "The grade of bootleg liquor has never been poorer."

The federal government's reaction to widespread abuse of industrial alcohol was to double down on poison—primarily the wood alcohol—making it almost impossible for bootleggers to remove it. Officials reasoned no sane person would intentionally drink foul-tasting poison. They were wrong. One dissenting senator said it was "legalized murder, and the government is an accessory before the fact."

The number of Kansas Citians affected is unknown, but newspapers carried stories of hospitalizations and occasional deaths from drinking poison alcohol. Some folks would drink anything. In 1929, the *Star* reported on a North Side drugstore that was selling three-ounce bottles of denatured alcohol, labeled as poison, for ten cents. Desperate down-and-out types believed a lighted match would burn off the poison. Known as "derail," this drink was said to kill four or five each week.

Another dangerous beverage was Jamaican Ginger, or "jake." Sold in drugstores as a stomachache remedy, it contained a high percentage of alcohol. One midtown drugstore blended jake with whiskey, to the delight of Westport High School students. Another jake cocktail mixed in chloral

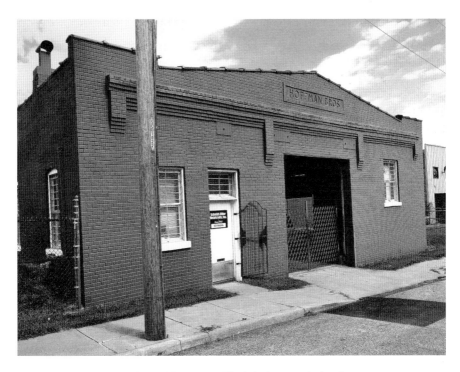

An alcohol stash was confiscated from 1321 Virginia Avenue. *Author photo*.

hydrate, also known as knockout drops. One man killed a cop after drinking such a mixture. "When that stuff gets to working I just have to shoot somebody," he said.

Joe Pasano, arrested at the Big 4 Transfer and Storage Company, once had run a North Side pool hall known to police as a jake parlor. The arrest apparently led nowhere, but in 1931, he got two years in Leavenworth for liquor conspiracy. Joe Pete died in prison in 1933.

1205 Independence Avenue

The low brick building near Independence and Forest sits just east of the downtown loop, separated by highways from its old neighborhood. In late March 1929, two men burst in here during a poker game, shot one of the players and stole cash and sugar. At that time, this was the North Side Distributing Company No. 2, a wholesale supplier of bootlegging supplies and corn sugar, a key ingredient in corn liquor.

Besides wholesale suppliers, a couple dozen retail bootlegger stores existed in Kansas City, like the Midwest Beverage Company on the third floor of the Manhattan Building near Seventh and Main (telephone and ask for "Cat"). You provided distilled or renatured spirits and expertise to concoct gin (alcohol, distilled water, glycerin, juniper oil) or rye (alcohol, sherry, distilled water, caramel coloring) or bourbon (alcohol, fruit flavoring, brandy essence, vinegar, glycerin, coloring) or even champagne (cider and seltzer). These shops sold (mostly illegally, per the Volstead Act) what you needed to make hooch look and perhaps even taste something like the real thing: pre-Prohibition bottles, counterfeit revenue stamps, corks, caps, capping machines, filters, clarifiers, charcoal for aging, coloring and flavoring agents and counterfeit labels for Johnny Walker, Canadian Club, Gordon's, Dawson's and more. And, of course, sugar.

In 1929, corn sugar sales were approaching a billion pounds annually, so farmers and their representatives in Congress did not much care that most went to the production of illegal alcohol. To them it was better than having bootleggers use Cuban cane sugar. In Kansas City, an estimated two boxcar loads per week went into bootleg booze.

Sugar sales, of course, were legal during Prohibition. A shortage during the world war led to a black market, and afterward, bootleggers created a new demand. In 1931, the *Journal-Post* reported the existence of a ruthless

A bootlegging supply house was at 1205 Independence Avenue. *Author photo.*

seven-year-old group whose original "plan was to sell corn sugar to all moonshiners and charge them a price greatly in excess of the market value" but had become a "plan for controlling all the underworld activities of Kansas City."

This group was a syndicate comprising several North Side sugar dealers, including former bricklayer James Balestrere and the DiGiovanni brothers, grocers Joe and Pete. According to author William Ouseley, Joe got involved in the Italian American extortion gang known as the Black Hand soon after arriving in Kansas City in the early 1900s. Both brothers had been fined for liquor violations: Joe for storing wine in his basement and a still on other property, Pete for selling wine to high school students. Balestrere also ran a grocery and later was linked to a speakeasy and a gambling club. But he developed great influence through the sugar business. Locals knew him to be polite and gracious, a man who could resolve community problems. Peers knew him as ruthless.

The three joined with others to form the sugar syndicate, which eventually ran the local bootlegging business. In Chicago's Little Italy, a similar group supplied stills, sugar, yeast and a nice daily income for people to make liquor,

then sold it to speakeasies at a profit. Kansas City's syndicate operated much the same way, according to Ouseley, eventually controlling the liquor business

> *from start to finish, raw product to finished product, and the equipment needed to deliver it. No one else could sell supplies to the bootleggers, and no one else could sell the finished product without a payoff to the syndicate. They controlled the sale or financing of all automobiles used by the group to deliver the finished product.*

The two robbers who shot up the North Side Distributing Company in 1929 were transplants from Brooklyn, known here as cousins James and Phillip Palmer. Their real names were Salvatore Piazza and Joe Vincetti. Relatives here were said to have convinced them money could be made in the local sugar business, even as syndicate competitors. They opened a sugar house and began selling below the fixed price. Threats came from the syndicate. The newcomers struck first at the North Side Distributing Company. Three weeks later, their well-dressed, bullet-riddled bodies were found miles away on opposite sides of the state line.

2932 Fairmount Avenue

The sleepy one-story stone-and-brick warehouse sits near a dead-end just off Southwest Boulevard. In 1927, this was the Tingle Oil Company, Joseph L. Tingle, president. On June 23, federal agents raided the plant and found two hundred drums of oil and the largest illegal brewery ever uncovered in Kansas City. Their haul included five one-thousand-gallon mash vats, twenty wooden beer kegs and beer-making paraphernalia. The beer tested at about 7 percent alcohol, way over the Volstead limit of $1/2$ of 1 percent. It appeared to be the primary source of the real beer turning up in soft drink parlors around town, quietly sold as "Chicago-style" brew. Tingle and his loading dock man were arrested. Tingle was charged with possession of beer and operating a brewery.

Before 1920, many saloons were owned by breweries. Heim, Goetz, Muehlebach, Imperial and others sold their beer exclusively in these places. Most breweries closed at the outset of Prohibition—but not all. The new law allowed the production of the minimally alcoholic near-beer. Goetz, in St. Joseph, continued producing throughout and after Prohibition and, at one

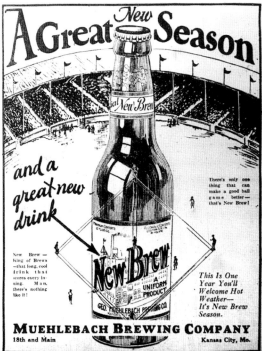

Above: The former Tingle Oil Company, 2932 Fairmount Avenue. *Author photo.*

Left: "New Brew" was served at Muehlebach Field. *From the Kansas City Journal-Post.*

point, supplied near-beer to more than one hundred Kansas City soft drink parlors. Muehlebach limped along in its plant at the corner of Eighteenth and Main before quitting in 1929. "It is impossible for an old-time brewer, abiding strictly by the law, as we always have done, to put non-alcoholic beverages on the market in competition with the present bootlegged liquor," said George Muehlebach, who also owned the Kansas City Blues and sold his near-beer at Muehlebach Field. He lamented "the home-brew crocks whose mysteries even the children of today have mastered."

Indeed, home-brewing was one method of getting real beer. A 1925 raid on a Westport house turned up five thousand pints of homemade beer, which the homeowner claimed was for his own consumption. Police knew the stretch of apartments along Paseo between Admiral and Thirteenth as "the brewery district." Bootlegging supply shops sold malt mash flavored like pre-Prohibition beer, lacking only yeast and filtering. Malt syrup was also available in grocery stores, where it avoided trouble by claiming to be a baking ingredient. Even so, one touted itself as the "Purest Barley Malt—blended with Hops."

Then there was "needle" or "thumbed" beer—near-beer shot with alcohol. Decades later, one old-timer recalled:

> *You'd take the near-beer and spill out enough so the level was just below the label on the neck. Then you'd pour in the grain to the point where the near-beer was originally. Then you'd put your thumb on the mouth of the bottle and turn the bottle upside down, mixing it. That's what you called "thumbing it."*

Real beer did find its way into Kansas City, either as product brewed illegally in other cities or brewed here under the control of outside interests. The latter is what agents found in their raid on Tingle Oil. Joe Tingle maintained he didn't know what he was getting into when he rented out space in his plant to Solly Weissman, a notorious, all-purpose local gangster with ties to Chicago racketeers. Tingle and Weissman also were charged for using the plant's rail siding to ship raw alcohol, but that case depended heavily on testimony of Tingle's loading dock man, Elmer Hoard. The trial was continued several times because Hoard had mysteriously disappeared. Finally, in 1930, the case was dismissed in federal court for lack of its star witness. However, Tingle was convicted of letting his plant be used as a brewery and sentenced to two years in Leavenworth. The judge called Tingle the "Kansas City agent of Chicago beer runners" and revealed that his $15,000 bail had been posted by his Chicago boss—Al Capone.

1141 East Fifth Street

Besides its many Sicilian families, the North Side was home also to immigrants from Eastern Europe as well as a small African American community. Stories tell of black cooks setting up barbecue pits in vacant lots—one was at the corner of Independence and Harrison—and grilling beef, pork and mutton in the open air, selling sandwiches for a dime.

It's a ten-minute walk from that corner to the two-story storefront building at Fifth and Forest. In 1921, the first floor housed the Friendship Baptist Mission, a small African American congregation that held revival meetings here. That February, the second floor and basement were raided by federal agents. They found stills, corn mash, forty gallons of moonshine and two thousand gallons of wine, what they called "Dago red." At the time, it was the largest booze bust in the city. Some Italians promised $40,000 for the name of the person who had revealed the cache. "We merely laughed," said one agent. "We don't want any Italian Mafia murders as a result of these arrests." The revivalists at Friendship Baptist Mission were absolved of any connection.

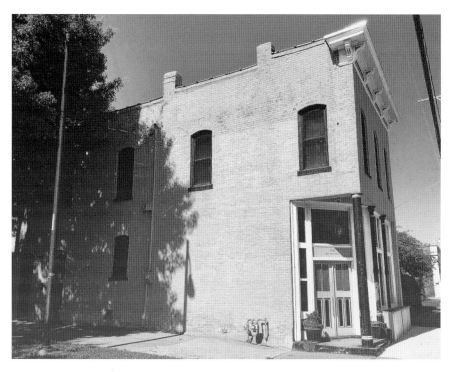

The former Friendship Baptist Mission, 1141 East Fifth Street. *Author photo*.

In the coming days, more North Side raids turned up more wine: 4,700 gallons in one basement. Several Italian families came forward and admitted they had wine, claiming it predated Prohibition. But they had failed to report their wine then, so it was confiscated. At the time, the law allowed production of up to 200 gallons of wine annually, tax free, with a permit, provided it was not for sale. And it was legal to keep 5 gallons in the home for personal consumption. One man told the *Times* if the raids didn't stop, some families would leave America:

> *We are so accustomed to drinking wine with our meals that we miss it just as much as the Americans would miss their coffee. It's bad enough to have to get along with the substitute wines we have been trying to make since the beginning of the war, but if we have to pay high attorney fees, fines and maybe prison penalties for having wine, we would rather go back to Italy.*

In November 1925, the government rescinded all permits to make wine in the home. Three days before Christmas, agents raided a home near Friendship Baptist Mission. A family sat at table, eating bread and drinking wine. The mother pleaded.

"Oh, mister," she cried. "I just made one barrel of wine this year, and it's no good. Honest. Besides, we've got so little. We Italians must have wine. The children want it. At least leave enough for Christmas."

Her young daughter joined in: "Oh, mama, now will we have to eat our Christmas dinner with the neighbors because they are taking our wine away?"

823 Walnut Street

The twelve-story Waltower Building at the corner of Ninth and Walnut was new in 1929. Today, someone lives in a sixth-floor loft apartment where, in January 1931, the office of the Ukiah Grape Products Company of New York employed about thirty salesmen. The product they sold was grape juice concentrate, which came with instructions that read: "Put juice in a warm place and open the stopper, let stand for up to a month." They carried flasks filled with a sample of the result and delivered their pitch based on the sales manual:

Highballs, Spooners & Crooked Dice

Good morning, Mr. Jones. I am around here quite a bit and I have been calling on some of your friends and they suggested that I call on you as you are a two-fisted sport. Would you be interested in a good class of pure, unadulterated, crystal clear, wholesome wine, with a percent of alcohol of from 14 to 18?

Unfortunately for the Ukiah Grape Products Company, the rest of the sixth floor of the Waltower Building was occupied by the federal prohibition office. After posing as prospective employees and attending a sales meeting, agents raided, arresting twenty-two salesmen. Only the manager was charged with the sale of alcohol. It would become the first test case against these type of companies. A confiscated sales pamphlet laid out the company's defense. "You have a perfect right to buy it," it said, "because when delivered it is nonalcoholic."

The Volstead Act permitted "wine for sacramental purposes"—a provision much abused nationwide—and California vintners profited. Ukiah Grape Products had been selling its product since early in Prohibition, sometimes with the "for sacramental purposes" disclaimer. Salesmen operated openly and confidently, and orders were shipped demanding cash on delivery. Other companies—the names included Vine-Glo and Vino Sano—similarly sought to play the system by selling unfermented juice and leaving little doubt about what could happen by letting nature take its course. One company sold juice in dehydrated "bricks" that carried a warning: "After dissolving the brick in a gallon of water, do not place the liquid in a jug away in the cupboard for twenty days, because then it would turn to wine."

The test case here made national news when it came before a federal judge in October 1931. Because it was a test, the verdict—guilty, based on the same section of the Volstead Act that outlawed bootlegging supplies—brought minimal penalty in exchange for Ukiah's cooperation: fines for the company and the sales

Waltower Building, 823 Walnut Street. *Author photo.*

manager. It turned out the national Prohibition office was not interested in prosecuting these companies; the Kansas City branch had acted on its own. As a result, the companies dropped their one-on-one approach and concentrated on grocery store sales. In his verdict, the judge pointed out that Ukiah's product, described as a grape juice, sold in stores at four times the price of grape juice.

1913 Broadway

The homely little garage sits on the Broadway hill a couple of blocks below the spectacular Kauffman Performing Arts Center. The building was just as unremarkable in 1925, at least until March 7 that year, when a cache of genuine bonded liquor—Haig & Haig scotch, Canadian Club whiskey, Gordon's gin, Pol Roger champagne, Chasternet Freres Bordeaux wine and more—turned up here, stacked behind bags of Pelican brand oyster shell grit. A federal agent assessed its bootlegging value—diluted with distilled water and alcohol—at $200,000. A similar supply had been found earlier in the East Bottoms, a boxcar load packed in the same crushed oyster shells used in the South to pave roads and feed chickens. The boxcar had been consigned from Biloxi, Mississippi.

"Apparently immensely wealthy men are behind the traffic," said the district attorney. "No small fry could risk losses sustained recently in Kansas City alone." Police immediately sought to question two men, Ray Broom and Fred Shofstall.

Biloxi, on the Gulf of Mexico, had been serving as a port of entry for fine liquor from Cuba, the Bahamas, Bermuda and Belize. A bootlegging ring was shipping it upriver to St. Louis, Chicago and Kansas City. In 1924, it was a reported $3 million business, employing nearly 1,200 men in its transport chain. It involved fast boats, railroad freight cars, Pullman passenger cars with hidden compartments, trucks, autos and wealthy clients.

Before Prohibition, Ray Broom had served nine years in the Illinois state pen for murder and had arrests for auto theft in St. Joseph and robbery in Kansas. Shofstall also had a police record for burglary and other offenses and had gone to work for the family hay dealership in the Livestock Exchange Building. The two began bootlegging by driving carloads of bonded liquor from points east to Kansas City. When highwaymen and police shakedowns made long-distance automobile transport hazardous, rail

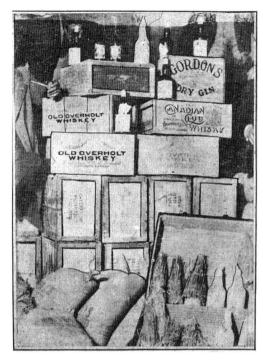

Left: Liquor shipped from Biloxi, 1925. *From the* Kansas City Journal.

Below: Booze and oyster shell grit were found at 1913 Broadway. *Author photo.*

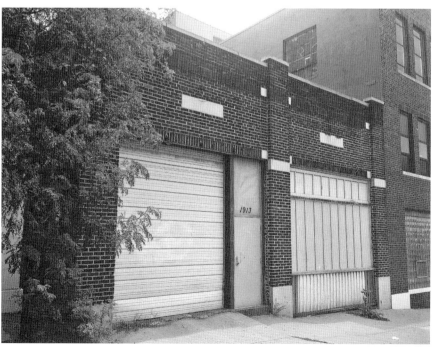

became the preferred mode. One boxcar could carry hundreds of cases. A thrifty bootlegger could dilute the imported booze, affix top prices and reap a small fortune.

In early 1925, police received a tip, presumably from a competing bootlegger, about the Biloxi shipments. They learned the Broadway garage had been rented by Broom and Shofstall. Both fled town, waited several weeks for things to cool off, then returned. Mysteriously, no charges ever materialized.

At one point, Shofstall was described as "the master bootlegger of Kansas City." He was shot dead outside his Linwood Boulevard apartment in 1928, possibly by competitors. The murder was never solved. Broom, eventually called "Kansas City's reigning bootlegger," avoided trouble until 1929, when he sold alcohol to federal agents. That brought a cascade of charges, including income tax fraud and involvement in a local ring with connections to Al Capone, which put Broom in Leavenworth for two years. "I've made a million dollars in this game since 1928," he said at his tax trial. "It's all supply and demand, you know."

803 Walnut Street

The street-level front of the Gumbel Building, today a hotel, has been modified several times since it was built in 1904. In 1922, a restaurant called Gumbel Lunch occupied space behind the first window north of today's hotel entrance. Gumbel Lunch undoubtedly served the tenants of the building, including doctors, lawyers, real estate agents and one T.J. Pendergast, whose Jackson Democratic Club then operated on the fifth floor.

Early that February, a mud-flecked car with Kansas tags pulled up, and a man and woman emerged, entering Gumbel Lunch. The proprietor, Frank "Chee-Chee" DeMayo, greeted them. The woman had told DeMayo she had a friend in Kansas who sold liquor and was interested in buying more. They settled on two cases of whiskey for $300. DeMayo's assistant, Robert Carnahan, fetched two cases from another location, money changed hands and cops materialized to arrest DeMayo and Carnahan. The money was marked, the buyer an imposter, the bootleggers' auto an unmarked cop car hand-splattered with Missouri River mud. DeMayo's notebook listed prominent Kansas Citians who paid up to $160 for a case of liquor.

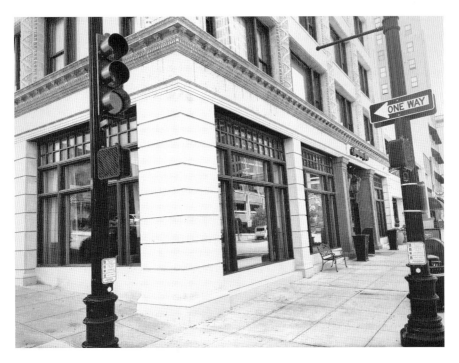

Gumbel Lunch operated at 803 Walnut Street. *Author photo*.

Over time, several liquor salesmen were referred to as the most successful bootlegger in town. Ray Broom and Fred Shofstall were two. Another was Guy Brock, called the "the peacock of Twelfth Street" for his reputation as a "wearer of pearl gray spats and with grand manners of the kind that impress newsboys," as the *Star* said. He found work before the world war at a stockyards packing company, but his future was set when he took over a Twelfth Street cabaret. His Prohibition job titles included proprietor of a booze-selling drugstore near Twelfth and Baltimore and later a soft drink parlor; operator of one of the largest stills discovered in Kansas, in the Merriam hills; and per the 1930 census, "wholesale salesman." In November of that year, Brock was arrested after selling alcohol to federal agents. He avoided a stiffer sentence by pleading guilty, but did three years in Leavenworth. Brock, too, once inspired someone to call him "the town's kingpin bootlegger." In truth, he had been an associate of Frank DeMayo.

DeMayo was, in fact, the consensus "king of the bootleggers," with what was called one of the country's largest illegal liquor operations. Once among the city's top gamblers, he put his winnings into Oklahoma oil fields before

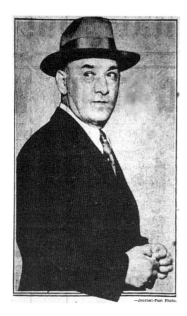

Frank "Chee-Chee" DeMayo. *From the* Kansas City Journal-Post.

bootlegging became his primary livelihood. In the Gumbel Lunch sting, Carnahan ended up taking the fall for his boss, setting a precedent for the system: DeMayo worked behind middlemen to escape prosecution. Becoming strictly a wholesaler, he built a regional network of soft drink parlors, drugstores and other retailers.

When bonded liquor became too costly and difficult to obtain, DeMayo moved into homemade booze. Although marketed as fine liquor straight from New Orleans or Detroit, it was created in his various processing plants from denatured alcohol or moonshine from stills he sponsored. He paid off police and federal agents—reportedly declaring "no $140-a-month copper could put me in jail"—then passed that cost on to his retailers. If they were caught, he would pay them to keep silent and serve jail time.

DeMayo set up shop across the street from the federal courthouse on Grand, in an office behind one of his drugstores. The drugstore was padlocked after the proprietor went to jail for liquor violations, but the office stayed open. An intensive government effort to catch DeMayo red-handed put agents with binoculars in the adjacent Gumbel Building, upstairs from his old restaurant. He learned to recognize agents, but one finally caught him in a sale in 1927.

Both DeMayo and Carnahan were charged with sale of liquor and counterfeit revenue stamps. It took a year and four trials to get a conviction—tampering led to three hung juries. Intending to appeal, he suddenly surrendered in 1929, pleaded guilty and got two years in prison. Before relinquishing his bootlegger crown, he spoke to reporters.

"I'm folding up," he said. "I'm through. I'm going to take my medicine and quit. There's nothing to this business."

3
Four Highballs

Where you drank your booze had a lot to do with how you drank it.

With Prohibition, former saloons became soft drink parlors, supposedly selling only sodas and near-beer with less than ½ of 1 percent alcohol content, the legal limit. These, with the addition of liquor, became one type of speakeasy. Others included corner drugstores, swanky cabarets, cafés, hotels and country roadhouses, as well as private homes. Raids kept many of them moving from one location to another. But any place where a bartender kept a half-pint of corn liquor in his back pocket could be called a speakeasy.

Cocktail histories are typically New Yorkish and Eurocentric in their exotic inventories of Prohibition-era drinks, and there's not much documentation of what was served in Kansas City. A big 1932 raid on the city's largest speakeasies "revealed that drink mixing has not become a lost art, as many supposed," according to the *Journal-Post*. Bartenders using synthetic booze "had reached such a high degree of efficiency with tints and syrups that some of the old time tipplers imagined they were drinking such forgotten beverages as sloe gin rickeys and the like." Drugstores sold nonalcoholic cordials in flavors like Martini and Manhattan, to which you could add the necessary "jolt."

Shortly after repeal, nightclubs were able to advertise cocktails, suggesting what had been popular before: Manhattan, old-fashioned, whiskey sour, Sazerac (whiskey drinks); Bronx, Tom Collins, martini, Pink Lady, rickeys and fizzes (gin); Bacardi (rum); sidecar (brandy); and what was surely the simplest and most popular, the highball.

Author Paul Dickson describes the highball as a "family of mixed drinks that are composed of an alcoholic base and a larger proportion of a non-alcoholic mixer. The literature of the Dry Years is awash in Highballs." As was Kansas City. In 1920, a *Star* reporter ventured into the Café Roma on the North Side and wrote about it:

> *"Four Highballs," ordered the leading spirit at one table, and the waiter departed. He returned with four tiny glasses, each containing a few thimbles-full of diluted whiskey. He collected at the rate of $1 a drink, waiting ominously for his tip, which he pocketed without thanks.... "This is hardly what I expected," complained a woman at one of the tables, who was on her first expedition into Little Italy.*

That's another element of cocktail popularity: women drinking in public. Before Prohibition, saloons were for men only. In 1920, women gained the right to vote and sudden social equality. "The new order of things had put the gentlemen-only saloon and hotel bar out of business," noted Dickson, "and what replaced it was a new cocktail culture where women drank with men."

Of course, there were hardcore drinkers who took their booze straight from a flask or pint bottle, whether in a speakeasy, the backseat of an automobile or a dark alley.

1131 East Thirty-First Street

Walt Disney maintains a presence at the corner of Thirty-First and Forest. His face stares down from posters covering the windows of his old Laugh-O-Gram Studio on the second floor of what's left of the McConahay Building, built in 1922. Laugh-O-Gram operated upstairs from that year until the summer of 1923, when Walt ran out of money and took his cartooning talent and collaborators to Hollywood. The shell of the McConahay Building is now maintained by Thank You, Walt Disney Inc., in anticipation of its renovation as a museum and workspace. A welcoming center is planned for the first-floor corner once occupied by the South Central Pharmacy, a bootlegging drugstore originally part of Frank DeMayo's illegal booze network.

A drugstore was a place to buy liquor legally. People still considered whiskey a remedy for certain ailments. With a physician's prescription, you could get

The former South Central Pharmacy, 1131 East Thirty-First Street. *Author photo*.

a pint for "medicinal purposes" in any drugstore that held a government permit. Government liquor was bonded, distilled in Kentucky and stored in warehouses, seven of which were in Missouri. Abuse of the system was widespread. Disreputable physicians sold individual prescriptions, or they sold blank, signed prescriptions to bootlegging druggists. There were counterfeit permits and counterfeit booze, mixed in back rooms using denatured alcohol and flavorings, cut and sold as bonded liquor.

In 1925, DeMayo's South Central Pharmacy ran afoul of the liquor laws, and that summer, the place was padlocked as a nuisance and sold. It reopened as the Isis Pharmacy with a clerk named Max Ducov behind the counter. A son of Polish Jewish immigrants, Ducov hawked newspapers as a boy and once attempted to travel the world by selling papers in cities and towns along the way. Later, he was described as an alleged "short-change artist." In 1923, he was arrested in a Chicago hotel with $5,000 worth of heroin, for which he spent six months in jail. Back in Kansas City, he found work as a deputy county clerk and tax collector. Then he discovered there was more of a future in drugstores.

In March 1926, a delivery boy at the Isis Pharmacy told an assistant prosecutor he had seen Ducov and another clerk selling alcohol and mixing drinks for friends and young boys. Two months later, police found whiskey and grain alcohol in his garage. Ducov got a year in jail and a $1,000 fine, and the store was again padlocked.

With Prohibition, the number of drugstores here doubled. By 1923, there were more per capita than any other city. "Under the open saloon there were between six hundred and seven hundred liquor houses in Kansas City," said the city health commissioner. "There are almost that many drugstores in Kansas City right now."

The amount of whiskey the government permitted stores to sell was based on the volume of overall business, which led stores like Katz to cut prices to sell more prescription liquor. Legitimate operators weren't happy about the imposters. "A man who operates a drugstore only to carry on a whiskey trade is a detriment to the public health," said one member of the Retail Druggists' Association. "Such men have no interest in safeguarding public health." One angry druggist took out a newspaper ad: "Under the present ownership and management we have not carried, and do not now carry, any stock of intoxicating liquor. We fill absolutely NO 'Booze' Prescriptions."

Many druggists were former saloon keepers with dummy inventories of cigars, candies and pharmaceuticals disguising the real business of the soft drink counter. At one store near the Livestock Exchange Building, agents found shelves of empty packages, bottles and cartons.

"The only thing of a drug nature actually present were a few aspirin tablets," said one agent. "The rest was booze."

423 Southwest Boulevard

Today, you can eat fried pickles and play Skee-ball in the bar and nightclub inside the two-story brick building at Southwest Boulevard and Washington. It's probably safe to say no one has recently died of diphtheria there, as the eight-year-old son of Abe Grandstaff did in 1910, when the family lived in rooms over Grandstaff's saloon. And it's surely been a while since anyone found a 1908 penny on the floor there, as a policeman did in May 1923, when it was known as Grandstaff's soft drink parlor, and the cop wished on the coin for good luck. The police booze raiders had searched several

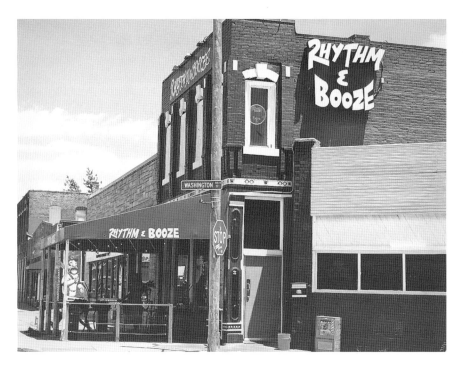

Grandstaff's former saloon, 423 Southwest Boulevard. *Author photo.*

joints that night, finding nothing illegal. They remained hopeful, peeking underneath the bar, opening drawers.

"Prohibition and the bootlegger," a *Journal* reporter wrote in 1926, "have brought back the underground passageway, the camouflaged cavern, the trap door and the magic password of the Middle Ages." Everywhere in Kansas City were elaborate systems of deception such as the spring-loaded trap door that, in the event of a raid, would drop full glasses or bottles of booze from the bar back to the concrete basement floor; the plumbing system that dispensed alcohol from a water faucet; and the rubber tube that delivered corn whiskey from a ten-gallon tank through a hole in the wall covered by a picture of William "Pussyfoot" Johnson, a famous anti-booze crusader of the day.

Soft drink saloons used loose floorboards, false wall panels and secret rooms. Police found booze creatively stashed in an old organ in a vacant church, a milk bottle painted white, the upholstered back of an automobile seat, a box marked "polish" at a shoe-shine parlor, a rain barrel with a false bottom, a backyard pile of ashes, a rose bush, a barrel of spinach at

a produce stand, a bin of buns at a hamburger stand and baskets of corn being delivered.

Some joints took to keeping liquor somewhere outside, sending a runner to fetch the bottle whenever a safe customer ordered a drink. One speakeasy stashed it behind a clock's face. If the clock's hands were moving, the law was nearby; if they were still, the question "What time is it?" brought forth the liquor. Another place had a secret panel that concealed not only a supply of whiskey but also cocaine, morphine and opium. A barbecue stand stashed its booze in one of five black coffins stored in the basement. As police carried it out, a crowd gathered, and one person remarked, "They ain't got no respect for the dead."

Back at Grandstaff's that night in 1923, the cops kept poking around. The bartender poured himself a glass of water, whistling. Abe Grandstaff smiled. He was fifty-six, a tough old-time saloonkeeper who, one night in 1901 at his bar in Rosedale on the Kansas side, drank too much of his own stuff, pulled out a pistol and demanded one of his customers dance a hoedown, shooting at the floor and wounding a bystander.

Grandstaff's smile faded as one cop noticed a nail in a board on the wall behind the bar. The lawman tugged at it, and the board hinged open on a nest for eight pints of whiskey.

818 Baltimore Avenue

Sometime after 1976, when preservationists rescued the Bunker Building—on Baltimore just north of Ninth—from parking lot oblivion, the building's 1881 façade changed. Gone now are three original basement-level storefronts with stairways descending from the sidewalk. In 1928, the first door north of the arched main entrance was a high-end cabaret known as the Submarine Inn. A *Post* reporter described it as a place where "young girls—some of them from respectable families—are to be found sitting at the tables drinking with youths of questionable character, or dancing in a manner not permitted in properly supervised dance halls." What's more, "many of the patrons are married men and women—not always present with their own wives or husbands."

Cabarets—with music and floor shows—could be found downstairs, upstairs, behind secret doors or operating openly. Before Prohibition, the most popular were in hotel basements. The Jefferson Hotel, owned by Tom

The former Submarine Inn, 818 Baltimore Avenue. *Author photo*.

Pendergast, was constantly defending its liquor license against charges like "harboring women of known bad character." The Blue Goose, in the Hotel Puritan, advertised early on as "The Finest Spot in Kansas City," soon was known to police as "another night resort frequented by underworld characters." The finest was in the Edward Hotel.

The Edward was run by Joseph Donegan, "the angel of Twelfth Street," probably the best example of a successful prewar cabaret proprietor victimized by Prohibition. He was said to have made and lost several fortunes as a gambler and fight promoter, including a huge loss betting on the scandalous 1919 World Series. He spent easily but also gave to anyone in need, beggars or friends, hence his angelic nickname. From 1908, he had run the Century Theater at Twelfth and Central (today the Folly) and the adjacent hotel. The hotel accommodated musicians, burlesque performers, boxers and wrestlers who worked the theater, and the hotel's basement café—called "Kansas City's brightest spot"—was where locals mixed with celebrities like Jack Dempsey, Fanny Brice and Eddie Foy. Although Donegan was a Pendergast friend and was said to have police protection, the cabaret became a frequent target for government raids during Prohibition and, in 1923, was finally padlocked for liquor violations. It reopened in 1926 as the Nightingale. The next year, a singer was shot dead there by a bootlegger.

One night in 1928, bandits burst into the Submarine Inn and relieved customers of several thousand dollars' worth of cash and jewels, probably figuring—correctly—that illegal liquor and gambling would preclude filing a police report. Federal agents raided later that year, and the Submarine was padlocked in 1929.

That year, a *Journal-Post* ad announced the opening of Cuban Gardens, a cabaret/casino north of the river with "excellent cuisine" and a sixteen-piece orchestra, owned by Johnny Lazia and managed by Joe Donegan. The place was short-lived, and Donegan died the next year after a heart attack. The *Times* called him "perhaps the best known man in Kansas City's night life." He reportedly died broke and sad. "You never see a man whistling on the street since Prohibition," he had said.

3403 West Fifty-Third Street

Over in Fairway, Kansas, a mile west of State Line, three nineteenth-century buildings are known collectively as the Shawnee Indian Mission Historic Site. The mission was built by a Methodist minister wanting to convert the Shawnee after their relocation to Kansas Territory from Ohio. A sign outside the East Building says it "provided a chapel and classrooms, and living quarters for teachers. Indian boys slept in the attic." An update would

mention the summer of 1921, when the building also provided tables, a dance floor, a jazz orchestra, private rooms, fried chicken and bootleg liquor.

That March, the Kansas legislature had failed to pass a bill to restore and preserve the historic buildings, in part because western Kansas representatives saw little bang for their bucks. The Kansas City woman who owned them then rented the former chapel building to one Aaron "Jack" Copelman, who before the war had run a gambling den at Twelfth and Grand. Copelman spruced up the entrance with shrubs and flowers and an arched gateway identifying it as a "chicken dinner farm."

During Prohibition, chicken dinner farm was a euphemism for roadhouse. They dotted the countryside beyond the city limits, mostly in Missouri. The fare at each was similar: chicken, liquor, music, dancing, possibly gambling, possibly rooms for private parties. The names included Edgewood (97th and Prospect), Webb (89th and Prospect), White House Tavern (82nd and Troost), Oakwood (21st and Blue Ridge) and Indian Inn (State Line at Dallas Road, now 103rd Street). Jackson County sheriff John Miles led numerous raids on them with the cooperation of a war buddy who had become a Pendergast-backed county judge, Harry S. Truman. A Truman biographer

Jack Copelman's former roadhouse, 3403 West Fifty-Third Street. *Author photo.*

has wondered whether the raids came because payoffs to the machine were harder to collect in rural areas.

In June 1921, a *Star* reporter visited Copelman's new Kansas roadhouse, which was drawing "nightly frequenters of the downtown cabarets in the old days." He observed whiskey being served in china cups and that "girls in ultra-modern dress sit about in unconventional poses, eating and drinking, jesting and dancing."

On June 30, Johnson County sheriff's deputies raided, found liquor and arrested Copelman, who then served the raiders chicken and blackberry pie. "No liquor joint or immoral resort can be operated in Johnson County by Kansas City thugs or anyone else," declared the county attorney. "They will learn that we are a law abiding and law enforcing people over here."

"Thug" seemed a harsh judgment. Years later, a *Times* columnist recalled Copelman

> *had gone from the betting shops here to the battlefields of France....He was wounded in the Meuse-Argonne and while lying in a dressing station learned his commanding officer was missing. He remembered the officer had been at his side when a shell exploded so, without a word to anybody, Jack returned to No Man's Land, found the officer, and took him back to safety.*

Copelman suffered lung damage from a poison gas attack the night before the Armistice was signed but returned home and reopened his downtown cigar stand/gambling joint. A St. Louis reporter stopped in and later wrote, "The play was heavy, real money in sight, and through the series of rooms blackjack, faro, craps, poker and roulette was going on." Copelman's war record served him well after an arrest. "Jack Copelman has more courage in his little finger than you have in your entire body," the judge told the arresting cop. "He is beginning anew, and you, even before he gets out of his uniform, arrest him for a vagrant without evidence. It's an insult to the flag, to the country, and to every red-blooded American."

Good character and connections failed him at his Olathe trial in 1921. He paid a fine and served most of a four-month jail sentence, winning a late parole after doctors diagnosed him with tuberculosis traced to the wartime gas attack. While being treated in the Kansas City Tuberculosis Hospital in Leeds on his birthday in 1923, Copelman called some friends together.

"I want you to give these people at Leeds a party for me," he said. "I want you to give them a Christmas party each year, too. Do the job right and I'll help you all I can."

618 West Forty-Eighth Street

It was one of the first retail buildings at the west end of the Country Club Plaza, built in 1930. The middle of three original storefronts is now the center section of a Mexican restaurant that occupies the entire building. In March 1931, this was a café, a popular hangout for high school and college students called the Chat 'n' Nibble, run by a guy named Harry Zerbst. Kids liked its honkytonk atmosphere—sandwiches, tables, low lights, a small jazz group, blonde waitresses, slot machines, liquor. People drank highballs, danced and sang until the early hours.

Zerbst, then thirty-five years old, was the son of German immigrants. A former soap salesman, he had come here from St. Joseph after the war and was divorced with a thirteen-year-old son. Zerbst had been living across the street from the Chat 'n' Nibble in the Vanity Fair apartments, but a recent downturn in business—the Depression was real—had him sleeping on a cot in the café's basement.

One night that March, some young policemen posing as students infiltrated the regular Chat 'n' Nibble crowd, stood up, confiscated some highballs and

The Chat 'n' Nibble was located at 618 West Forty-Eighth Street. *Author photo.*

a gallon of liquor and arrested Zerbst and his staff. Complaints had come in from parents and residential neighbors.

Free on bond, Zerbst fell into despair. "If I had listened to your mother, I never would have been in this jam," he told his son. The boy asked his father about a vial of white powder he was carrying. "I guess this must be poison," Zerbst said. "Have you ever read of people taking poison?"

Readers of the local newspapers had become familiar enough with suicide. Some cases were sensational. There was Harry Smart, a wholesale grocery salesman who in 1920 lost money in gambling dens and drank carbolic acid in a hotel room. "I lost my week's salary and $70 in commission," his note read. "This will account for my act." A similar case was Holly Hensley, an executive with an automobile rental service. In May 1928, he shot himself in his office after scribbling a note to his wife: "I have been gambling heavily. Tried to beat back, but kept going in deeper....If the police department would keep such places closed this kind of thing would never happen. I am crazy as a bedbug....Love and a million kisses—Your husband that was, but ruined by KC gamblers."

Then there was D.M. Carey. Carey had run a saloon in the old days but became familiar to police as a "well-known bootlegger" with a series of drugstores and joints. One was in the original Gillis Opera House building at Fifth and Walnut. After the Gillis burned down in 1925, he opened a much-raided-and-padlocked drugstore on Main. He paid fines but did no jail time. Carey's son, a wounded war veteran who went by the name "June," was a partner.

In August 1929, an explosion and fire in a drugstore on Prospect killed three firefighters. Fixtures in the store were traced to the Careys. Police determined they were part of an arson ring collecting insurance payoffs. As a grand jury heard testimony that also implicated Carey Sr. in the earlier fire that destroyed the Gillis, he was in a dingy hotel room, putting a bullet in his head. The note he left blamed "the *KC Star* paper—drunkards—blackmailers and backbiters." His son was charged with murder in the Prospect blast but went free after a witness disappeared.

One morning, four days after the Chat 'n' Nibble raid, Harry Zerbst checked into the Hotel President. He put on pajamas and laid out a series of notes to various relatives, employees and law enforcement officials. Then he mixed his white powder—cyanide—in two glasses of water, and drank them both. One of his notes read: "Please set all my employees free. Blame only me."

927 McGee Street

The massive art deco structure on McGee Street between Ninth and Tenth is now part of downtown's residential/retail rebirth. In March 1931, the block-long building was seven months old and big enough to include a bus terminal, the KMBC radio studios and the eleven-story, five-hundred-room Pickwick Hotel, advertised as having "the hospitality that made famous the old English tavern." Apparently, the bell captains and staff took that boast literally, for they discreetly provided guests bottles labeled "Piccadilly," "Old Grand-Dad" or "Johnny Walker."

Upon receiving a request and $7.50, for instance, a bell captain would fetch a pint from room 301 and have a bellboy deliver it to the guest's room. On the first of March, the traveling salesmen in room 302 received their delivery, revealed themselves as federal agents and arrested two bell captains and five bellhops. The liquor, they determined, was low-quality homemade.

There were rumors about bellboys making small fortunes in their jobs. A *Liberty* magazine story in 1924 sought the truth from New York bellhops. Guests were said to tip an average of about twenty cents. Multiplied over a

The old Pickwick Hotel, 927 McGee Street. *Author photo*.

week and combined with salary, it was declared not uncommon for a bellboy to make up to seventy-five dollars per week. The article said nothing about the opportunities presented by Prohibition.

In fact, it was routine for hotel guests to make special requests of bellhops for liquor or for the location of a gambling game or for other forms of entertainment. Although they signed contracts not to violate the law, bellboys often had bootlegging connections. Some possessed pads of blank doctors' prescriptions for drugstore liquor. "You cannot lay all the blame against the bellboys, however," said one hotel manager. "In most cases the boys are used as messengers by the guests to procure liquor. We don't know where it is procured."

Bellhops knew the city's night life inside and out. "Immoral rooming houses would be few and far between in Kansas City if hotel bellboys and chauffeurs didn't supply the men patrons, and get a percentage of the money spent in the resort by the customer," said a police official.

The Pickwick Hotel incident was not the first of its kind. In 1922, federal agents masquerading as insurance salesmen arrested five bellboys at the Hotel Muehlebach and three across the street at the Hotel Baltimore. One bellboy said he paid eighty-five cents for the eight-dollar quart he sold an agent. They received fines in court and pink slips from their employers.

The Pickwick seven were not so lucky. The five bellhops went to county jail for three months; the two bell captains got a year and a day in Leavenworth.

6151 Paseo Boulevard

Except for overgrown shrubs and vines hugging windows and stucco, the house today appears much as it did in a 1925 photo, when it was the home of Bob Cook and his wife, Anna. Cook ran a drugstore at Fifty-Fifth and Paseo by day. At night he became proprietor of "Stagger Inn," as the Cooks' home was sometimes called by neighbors complaining of all-night parties there. Previously, the Cooks had lived at Fifty-Fifth and Harrison. Police forced them to move after similar complaints were heard in that neighborhood.

When cops raided this house in July 1925, they confiscated corn liquor, wine, home-brew, roulette wheels and other gambling devices. Cook's customers, it was said, were mostly South Side society women.

Illegal behavior was not confined to rough parts of town. Raids on Brookside homes found moonshine stills and equipment to make crooked

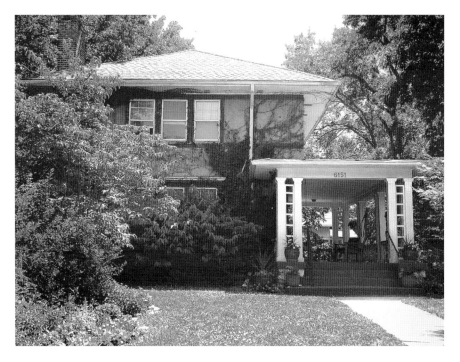

The former home of Bob Cook, 6151 Paseo Boulevard. *Author photo*.

dice. A home on Linwood boulevard, "believed to be one of the most richly furnished places in Kansas City," according to the *Post*, supplied liquor and cocaine and "beautiful and fascinating young women" who entertained "tired businessmen callers." The society weekly *Independent* worried about gambling among its readership. "It has been whispered that the lowly game of 'craps' has made its way into some of our best families," the magazine reported, "and that more than one maid and matron in our midst had confessed to a secret liking for 'rolling the bones.'" The principal of Central High School blamed the well-to-do for lax attitudes toward liquor laws. "It isn't the poorer homes that are our problem," he said, "but the homes of influence, the country clubs and social gatherings."

Prohibition had created those attitudes, as well as some new behaviors, like throwing home cocktail parties. Merchants took notice. According to author Paul Dickson:

> *Cocktail parties were virtually unknown and without a name until Prohibition. Along with what some have termed the Cocktail Age came a certain style complete with sleek chrome cocktail shakers, snazzy portable*

bars, Art-Deco-styled bar tools, and streamlined cocktail carts....The only reason one needed a shaker was to make a cocktail.

At Christmastime in 1922, the *Post* reported holiday sales of cocktail-making paraphernalia at an all-time high. Jewelry and department stores like Jaccards and Jones sold silver flasks, highball glasses and portable rolling bar sets with cut-crystal glasses, decanters, corkscrews, shakers and ice buckets. "The display of these things is a direct, though a thoughtless, defiance of the Prohibition law," a local dry advocate said in 1925, calling for merchants to stop advertising them. Private house parties continued.

Two weeks after the raid at Bob Cook's house, police raided a second time. Neighbors had reported well-dressed women arriving during afternoons for highballs and gambling. Later came the all-nighters. Police found it a nicely appointed home furnished with tables and chairs and accommodations for private parties upstairs. "To favored customers," the *Star* reported, "a curb service is conducted much as a drugstore extends 'honk-your-horn' fountain service to motorists. Two aproned girls, known to the neighborhood as the 'twins,' carry foaming steins and tingling glasses to cars in answer to honks."

The Cooks were arrested; however, their case apparently evaporated. By the following year, they had moved to a house at Sixty-First and Rockhill. Neighbors complained. Police raided and found liquor. Two men and two women were fined ten dollars for vagrancy.

4
Greed, Vice and Sensuality

I f you attended church in the 1920s, you heard about liquor and its attendant evils.

The energy behind the Eighteenth Amendment came from religious leaders and social reformers. In Kansas City, pastors devoted entire sermons to booze and vice. No group was more influential than the Woman's Christian Temperance Union, which had a representative branch here. On the sixth anniversary of Prohibition, the local WCTU published an enemies list, including:

- *Bootleggers, rum-runners, distillers and men who lost their jobs with Prohibition;*
- *"Personal Liberty" advocates—citizens who put self-indulgence and appetite before the welfare of the nation and the home;*
- *Pagans who do not recognize right and wrong, who are unmoral. A type often found in so-called intellectual and fashionable circles.*

Immorality also was defined by another local organization with ties to the religious community: the Society for Suppression of Commercialized Vice (SSCV), formed in 1913 in response to the death of a high school–aged prostitute. One of its stated objectives: "To promote education for the highest standards of public and private morality."

The spokesman of the SSCV was Nat Spencer, a former school superintendent and executive secretary of Church Federations of Greater

Kansas City. In the society's annual reports, Spencer identified the city's many roads to perdition: prostitution, "immoral shows," narcotics, lax parenting, "indecent publications," the automobile and "booze joints."

And then there was gambling. Missouri law prohibited gambling devices and games, including faro, roulette, keno and slot machines. Religious groups complained as gambling thrived in Kansas City, often in unconventional ways. In 1930, the *Times* told of businessmen betting on how many stops an elevator would make, lawyers wagering on how long a jury would need to reach a verdict, people betting on hourly temperature readings, the first letter of the main headline in tomorrow's newspaper or the numbers on the next arriving streetcar.

"The letting down of moral standards," Spencer wrote in 1923, "breeds discourse in the home, causes separation of husband and wife, and breaks up the institution on which much of our civilization must rest—the home."

205 East Ninth Street

At Grand Avenue Temple, a Methodist church near the corner of Ninth and Grand, Ionic columns and arched windows, lashed by weather and time, stand straight and tall as they did in 1912, when the building was dedicated. Except for the small air conditioner protruding from a stained-glass window, it probably looks much as it did in 1924, when Ira M. Hargett was pastor.

"The wolves of greed, vice, and sensuality infest our fair city, lying in wait to prey upon the innocent," Hargett declared from the pulpit here that year. He had come from Wisconsin in 1923 and was soon broadcasting sermons nationally (radio, he said, was God's work) over WOQ, a station owned by the Unity School of Christianity. That night, he praised Kansas City for beautiful boulevards, residential neighborhoods, schools and industries, but said it

> *bears the stigma of vice and crime. Bootleggers, robbers, thieves, murderers, prostitutes, drug fiends, and narcotic peddlers prey upon an almost helpless populace. There is, too, the hypocrite who uses the guise of church affiliation to conceal underhand dealings.*

Hargett, a Ku Klux Klan defender and president of the Society for Suppression of Commercialized Vice, was perhaps the loudest of several

Grand Avenue Temple, 205 East Ninth Street. *Author photo.*

religious leaders decrying the city's many varieties of vice. He imagined a special place in hell for the police. "Gambling of all kinds is rampant," he said in 1926. "I know of places where dice games, card games and policy games flourish without police interference. But why should I go to the police and lead them to these places? They already know about them."

A pastor with similar views was Albert Gaffney of the Northeast Presbyterian Church. An actual KKK member ("I esteem it an honor to be thus known," he once said. "The Klan stands for clean Americanism."), Gaffney also served as vice president of the National League to Maintain and Enforce Prohibition and Other Laws. "Eighty-five percent of the members of the police force are drinkers," he declared in 1925.

Some were more liberal. Leon Birkhead, minister of All Souls Unitarian, had been ordained a Methodist but came to reject fundamentalism. "I do not care a snap of the finger about keeping men out of hell and getting them into heaven," he once said. "But I do care tremendously about making the earth more like heaven and less like hell." He advocated for birth control and social responsibility and opposed the Pendergast machine. "We cannot abolish all wickedness," he noted in 1930. "Cities have always been wicked

Prohibition in Kansas City, Missouri

Left: Fannie Taylor. *From the* Kansas City Journal-Post.

Right: Ira M. Hargett. *Missouri Valley Special Collections, Kansas City Public Library, Kansas City, Missouri.*

and always will be somewhat more immoral than the country." But he was concerned about hypocrisy. "A good many of us are for Prohibition, but for the other fellow," he said.

Burris Jenkins was the pastor of Linwood Community Church. For three years after the war, he also served as publisher of the *Kansas City Post*. At church, he created innovative, controversial programs to expand membership among young people, including movie screenings and Sunday night dances. He befriended author Sinclair Lewis, in town researching religion for what would become the novel *Elmer Gantry*, and invited him to speak. (Lewis used the occasion to prove a vengeful God didn't exist by daring God to strike him dead in the pulpit.) Under Jenkins, the *Post* editorialized against liquor but came to criticize pastors "who try to make Prohibition a religious issue, who recklessly gamble the precious spiritual influence of the church upon the shifting forces of a legal device."

Hailed in the press as "one of the youngest and most progressive rabbis in the Jewish church," Samuel Mayerberg came to Temple B'nai Jehudah in 1928 from Dayton, Ohio, where he spoke out against vice conditions and police protection, as well as compulsory reading of the Bible in schools. Mayerberg made his name here testifying against corrupt city

government under Pendergast, which created a situation, he said, where "violations of the prohibition and narcotic laws are flagrant in Kansas City." He also blamed citizens for liquor lawlessness. "I feel we never shall have sobriety until people cease to sneer and joke about the law," he said.

Fannie Taylor was a longtime president of the state chapter of the Woman's Christian Temperance Union. "In dollars and lives Prohibition is a success, notwithstanding the howl about the high cost of enforcement," she wrote in a 1926 letter to the *Journal-Post*. "Prohibition does not make law breakers. It reveals them."

That year, she addressed a meeting of the Anti-Saloon League in the basement of Grand Avenue Temple. "Kansas City, Missouri, U.S.A., is the driest city in the world today of its size," she said. Then, the next speaker got up—the state Prohibition director.

"The situation in Kansas City is deplorable," he said. "More alcohol is coming into Kansas City than to St. Louis."

104 West Ninth Street

Around the corner from the former entrance to the Submarine Inn is the former entrance to the Orient Hotel, now a handsomely restored, four-story brick office building. Built as the nineteenth-century Lyceum office building, the Orient earned a twentieth-century reputation as a place to find a little action.

The Orient Hotel advertised itself as a "home-like" establishment of "modern rooms," offering "sulphur steam bath and massage for ladies and gentlemen." In early 1921, businessmen in nearby buildings began complaining to police about round-the-clock parties visible in a second-floor hotel room—crap shooters and poker players and large sums of money changing hands. A ground-floor soft drink parlor sold liquor. A raid in July netted eleven craps players and several hundred dollars. The case dissolved in court. The parties continued.

Finally, undercover federal agents checked in to the Orient and, over several days, built a successful case against the hotel in court. "The gamblers arrested in this place always were drunk," said a prosecutor. "The women taken in raids always were drinking women." He added that "lewd women" took men to the hotel and "registered as man and wife."

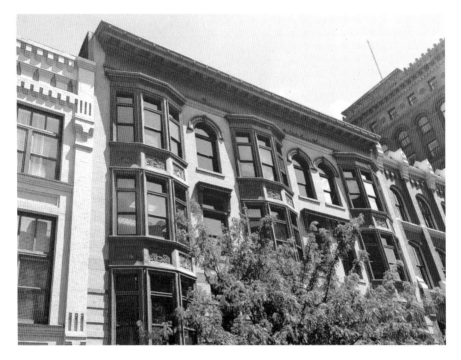

The former Orient Hotel, 104 West Ninth Street. *Author photo.*

The story of prostitution in Kansas City is as old as the city itself. Old-time saloons often had private upstairs rooms. A red-light district flourished, first in the West Bottoms and later on the North Side near city hall. A time-honored system involved monthly police raids on "immoral houses" and court fines for the women, who then went back to work. The fine system, said the police chief, "helps to regulate the red-light district and keep it in limits. Christ didn't stop immorality when he was on earth. That was two thousand years ago. It is still with us."

In 1913, reformers led by the new Society for Suppression of Commercialized Vice sought to end this system and close down the red-light district. In 1918, the city council passed an ordinance against the "bawdy house, house of prostitution or assignation," as well as "soliciting for immoral purposes upon the streets." The next year, a national public health authority wrote of "poor wretches who have been driven into the streets by misguided reformers." He said it was impossible for a man to walk the streets of Kansas City and other cities at night "without being accosted at least once by a former resident of the Red Light District. Prostitutes in these cities use doorways, vestibules, and even in remote cases church pews

in lieu of well ordered and clean bedrooms to supply their charms to those who will pay for them."

Change came slowly. Early in Prohibition, old-school brothels still existed, like that of Leannah Kearns, known as Annie Chambers, at Third and Wyandotte, said to have included crystal chandeliers, a mirrored ballroom and "a galaxy of feminine beauty." Another belonged to Agnes Keller, the "Duchess of the North Side," bold enough to tell the 1920 U.S. census-taker she ran a "bawdy house" at Seventh and Wyandotte. Chambers's place was padlocked in 1921. That same year, after a shooting in her joint, Keller left for Tijuana, Mexico.

Prostitution moved to rooming houses and cheap hotels. "Immoral women take rooms at these places at regular rates and, when used to entertain their men visitors, pay the proprietors an extra fee," said the SSCV's 1923 report. "This kind of business is encouraged rather than opposed by the proprietors."

From time to time, the SSCV listed specific addresses, providing notations such as "Gaudily painted white women solicit from windows" and "Vile solicitations by Negro women." Many clustered in the blocks east of Oak and south of Eleventh, like the rooming house at 1410 Holmes, run by a divorcée named Sadie Ash. Her two adult sons, Wallace and William, were found shot to death one night in March 1931, their bodies in a ditch beside their burning car on a rural Wyandotte County road. In exchange for narcotics to feed their habits, the Ash boys had become stool pigeons, alerting police to speakeasies and dives.

Police suspected revenge from bootleggers or drug dealers. Sadie Ash revealed another possibility. Two of her customers, William Miller and Charles Arthur Floyd, an escaped convict, had taken up with two of her "roomers"—Rose Baird, estranged wife of Wallace Ash, and her sister, Beulah, girlfriend of William Ash. Police eventually concluded that jealousy, and Floyd's belief that the brothers were going to rat him out, led to the killings. The Ash rooming house, it is said, was where Floyd acquired his infamous nickname: "Pretty Boy."

In 1927, the first female judge in Kansas City's municipal court, Tiera Farrow, heard a case involving nine women of the streets. "Bring in the men of the streets," she said, discharging all nine. "I think the men who are responsible for the activities of these girls are more guilty than are these defendants."

500 Walnut Street

The stone above the coffee shop door at the southwest corner of Fifth and Walnut identifies the "Gillis Opera House" and displays two dates. The first, 1883, commemorates the Gillis's opening as a grand theater attracting top stars and productions. The second, 1926, marks the debut of this second, smaller Gillis a year after an explosion and fire destroyed the five-story original. By then, the stage fare had long since devolved from opera to cheap burlesque.

Girlie shows at the old Gillis predated Prohibition. In 1919, a men's Bible class sent an investigating member to the notorious midnight show. He reported that "almost nude women danced and sang, walking through the audience," and the objective "seemed to be to put men in the frame of mind to visit immoral resorts." The Society for Suppression of Commercialized Vice found nudity on stage a trend in 1923. "When public opinion tolerates such immoral tendencies it is almost certain proof of the moral degeneracy of our times," it reported. "One of the worst offenders against decency has been the show in the old Gillis Theatre."

To moral crusaders, burlesque was "atrociously sensual and vulgar." American burlesque, always considered risqué, had grown more so by the 1920s. A city ordinance prohibited, among other things, "all indecent or lewd dress in theaters, [and] all indecent behavior," and religious leaders and women's groups demanded enforcement. Theaters felt the reformers' wrath.

Ads for the Gayety, at Twelfth and Wyandotte, declared "It's a Burlesque Show! You know you want to see one sometime—well, see this one. You'll never regret it!" (The burlesque debut of one Louise Hovick, later known as Gypsy Rose Lee, was at the Gayety in 1930.) After a raid of a show featuring comedian Billy Williams, police testified in court that "the girls wiggled and Williams' stories were raw." The Empress, at Twelfth and McGee, boasted "Never a dull moment," a claim confirmed by a women's club president who attended a matinee and reported "Beautiful girls making a show of themselves, squirming and twisting—oh, it was repulsive." After a raid at the Twelfth Street, on Twelfth near Grand, a dancer testified in court that she "might have removed some of her clothing, but her back was to the audience at the time."

Even the Shubert, at Tenth and Baltimore, known for legitimate theater, was called out in 1927 for "Gay Paree," a national touring production advertised as "Peeping through the keyhole at the night life of Paris."

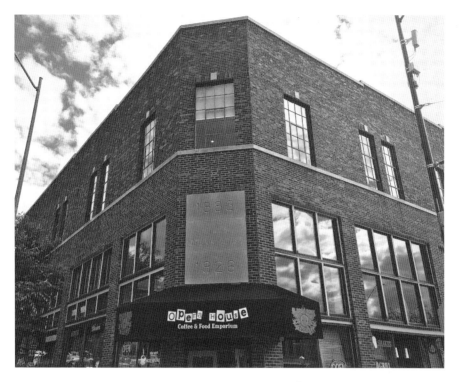

The second Gillis Theater building, 500 Walnut Street. *Author photo.*

Despite a content warning for "those who may not relish this exotic form of entertainment," the SSCV complained. J.J. Shubert responded. Kansas City, he said, was pretty lucky to be getting such first-class shows. The theater manager was even more blunt. "Those doing the most kicking probably seldom attend the theater," he said. "If Kansas City wants hick shows, we'll put them on a hick circuit."

Late on June 25, 1925, as a small Gillis audience watched a silent picture titled *Flaming Passion* and awaited the midnight show, a huge explosion rocked the old theater. The roof collapsed in the ensuing fire, and at first, it was feared as many as fifty people were lost in the rubble. Amazingly, only four died. Investigation centered on two businesses in the theater building, a jeweler and D.M. Carey's drugstore. A coroner's jury, however, could not determine the source and found no blame. The case remained a mystery until 1929, when Carey was implicated in another fatal explosion in another drugstore, this one an arson. His suicide followed a grand jury's linking him to the Gillis tragedy.

That year, 1929, reformers were pressing city officials for a new ordinance to license and censor theaters presenting girlie shows. One woman, a member of the SSCV's "wholesome entertainment committee," declared that if no action was taken, "a thousand more souls will go to hell." The city council took no action, finding the proposed ordinance discriminatory.

By then, the Gillis was back to seven performances daily, including two midnight shows.

525 GILLIS STREET

Like many old homes on the old North Side, the three-story residence at the southeast corner of Fifth and Missouri Avenue includes a former storefront. Today, a neighborhood art showcase occupies a former pool hall. In 1921, police raiders disrupted gamblers here during a sweep of known criminal haunts. Federal agents raided again in 1925, arresting a man who escaped prosecution by claiming he didn't know about the still in the basement; he was just watching others play pool.

Pool halls had a somewhat shady reputation by 1920, when the city directory listed 104. A year earlier, a public health official had labeled pool rooms "breeding places of iniquity" that "lower the morals of young men; sooner or later they learn to gamble and from gambling they try something worse until they are beyond recall."

Some proprietors—they preferred the term *billiards parlor*—took out newspaper ads declaring billiards was "O.K.'d by Your Doctor" as a means of stress reduction, and that "Mark Twain Often Played Billiards…Clean Sport for Regular Fellows." Probably the best known was Kling & Allen Billiards.

Johnny Kling had been the catcher for the 1908 Chicago Cubs—until 2016, the most recent World Series champs in Cubs uniforms. He was also a champion pool player, as was his nephew Bennie Allen. While Kling was still with the Cubs, the two became business partners in a pool hall at 1016 Walnut. After that building burned, Kling built the Dixon Hotel at Twelfth and Baltimore. The second and third floors housed Kling & Allen Billiards, which hosted many top pool tournaments. The parlor was no stranger to police raids; arrests were made there for gambling on pool as well as dice games. It was said to be under Pendergast protection, which usually meant no prosecution.

Highballs, Spooners & Crooked Dice

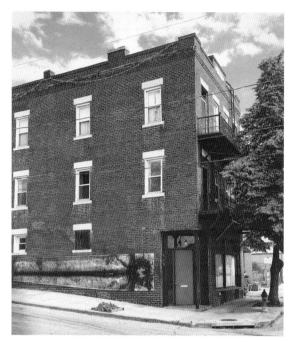

Right: A pool hall occupied the first floor of 525 Gillis Street. *Author photo.*

Below: A vertical sign on the Dixon advertised "Kling Billiards." *Anderson Photo Company Photograph Collection (K0489), State Historical Society of Missouri.*

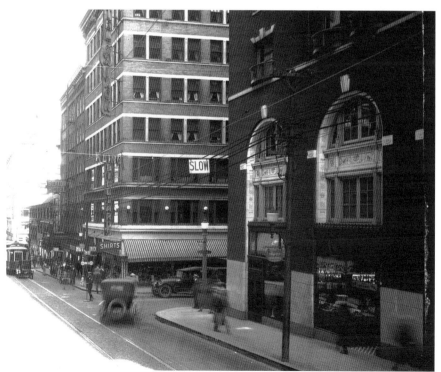

The Dixon Hotel also housed a basement gambling joint known as Baltimore Recreation, a bookmaking place in which Kling was a partner. Another former billiards champion, Tilford "Tiff" Denton," managed Baltimore Recreation. Denton had previously helped run the Hub, a notorious all-night combination pool hall/café/casino at Eleventh and Baltimore. In 1928, losses drove a gambler to shoot himself and leave a suicide note naming Denton among those responsible. In 1930, police arrested five patrons of Baltimore Recreation, after which the police chief vowed, "This town is going to be cleaned up of gambling and liquor resorts if I can do it." The five were discharged in court for lack of evidence.

In the 1921 raid on the Gillis Street pool hall, police arrested a man at the cigar counter. "I was on my way to get my marriage license," he said at headquarters. "A friend called to me to go in and get a cigar. He was congratulating me on my coming marriage when the police arrived."

Police checked out the story. "Certainly I was going to marry him," said the girl. "But where is he? He left this morning to go after the license. I have not heard from him since." The cops released him. The next day, he picked up the license. A month later, the couple married. In a few years, the place was known as the Gillis Billiard Room.

122 West Eighteenth Street

An artfully distressed door advertises sewing classes today where men smelling of tobacco once huddled around a display case of cigars, cigarettes and paraphernalia for smokers. In the 1920s, the city had more than one hundred retail tobacco shops, many in locations like Union Station, the Jackson County Courthouse, the Board of Trade, the Livestock Exchange, most hotels, even the lobby of Grand Avenue Temple. There were also small storefront shops like the Little Hollywood cigar store here on Eighteenth between Wyandotte and Baltimore, named for the neighborhood's studio film warehouses. William Flynn, a former city councilman and a prominent member of the Pendergast machine, was the owner.

Late in 1925, police began hearing complaints about a gambling game at Little Hollywood. It was a popular one called 26, the players rolling cups of dice for cash. The dice at Little Hollywood were said to behave oddly on the green felt playing board whenever the house operator was rolling. Cops raided and discovered four batteries under the cigar counter connected to

The former Little Hollywood cigar store, 122 West Eighteenth Street. *Author photo*.

a Ford automobile starter. Wires led to a humidor with a magnet inside. Pushing the starter button made the dice freeze, mid-roll, on favorable numbers.

Gambling wasn't unusual in cigar stores. Many had 26 games or crap tables. Bookmaking was common. One of the better-known operators was Harry Brewer, a former prize fighter. He lost his eyesight boxing but bought a cigar shop with savings and became a fight promoter and the "blind betting commissioner and bookmaker of Twelfth street," in the *Star*'s words. Brewer recognized voices and trusted regular customers in changing money; his longtime assistant helped deal with strangers. He was raided several times in the 1920s, always with resulting fines.

His shop on Twelfth had an unusual layout. A back door led to a soft drink saloon frequented by Brewer's customers. When a rival bookmaker set up a competing operation in the saloon, Brewer padlocked the entrance. He told a reporter the joint sold whiskey and had a crooked dice game

in the basement. "One touch of a button and the dice will stop on any number desired by the house, and the number usually appearing is seven, rest assured," Brewer said. He barred the saloon's patrons from his store, as they were "mostly thieves, bootleggers and gamblers."

Like his friend T.J. Pendergast, the Little Hollywood's William Flynn had risen in politics from the West Bottoms neighborhood and also operated several movie theaters, showing the city's first "talkies" at his Globe theater. When out-of-town promoters wanted to stage a dance marathon contest at Convention Hall in 1929, they asked Pendergast for a waiver of the ordinance prohibiting dance after hours. "If it's in the amusement line, you will have to see Bill Flynn," said the Boss. For $2,000, Flynn suspended the ordinance. A year later, he died in a plane crash at Fairfax Municipal Airport.

3504 Troost Avenue

The old McLaughlin Building today awaits redevelopment at the southwest corner of the once bustling Troost Avenue intersection with Armour. A bus shelter stands in front of the former drugstore and a haberdashery that did business here late in Prohibition. Offices upstairs included a medical clinic, a music school and an enterprise called the Saratoga Club, which, according to the city directory, provided "race results." Police once raided a similar place, arresting the operators for bookmaking. In court, they claimed they simply sold racing forms for a dime, the same information published in the daily sports pages. "Then I can't see how you can make a living selling racing forms," said the judge before fining them.

The biggest bookies operated downtown near Twelfth and Baltimore. South Troost was suburban at that time, although business was moving that direction and making downtown retailers nervous. Bookmaking was illegal, but boxing, baseball and horse racing were mainstays of sporting culture and, therefore, of betting. Police periodically announced campaigns to rid the city of bookies, but they were as ineffective as they were against speakeasies.

Kansas City's own racetrack, Riverside Park, opened in the spring of 1928 on the site of a former dog track. A year earlier, the state supreme court had validated the contribution system of betting, wherein a person could "contribute" funds at a racetrack window to help defray expenses of a sporting animal's upkeep and, in return, be paid from the beast's profits.

That September, the North Kansas City Greyhound Club—investors included Solly Weissman and Johnny Lazia—opened the first of two Clay County dog tracks a mile north of the toll-free Armour-Swift-Burlington Bridge. Twenty-five thousand spectators could place bets on dogs chasing a mechanical rabbit. A month later, the Fairview Kennel Club opened a rival track a little farther north and west, on the Parkville Highway. This ownership group included bootlegger Ray Broom. County officials and religious leaders opposed both tracks, as did a *Star* editorial: "It would mean a harvest for the professional gamblers at the expense of the gullible. It would mean the assembling of crowds composed largely of gamblers and other undesirables and the encouragement of rowdyism on the highways and the free bridge."

After a series of arson fires and bombings, which the rival tracks carried out against each other, opponents got an injunction. The next spring, the Fairview track was converted into Riverside Park, with seating for six thousand and stalls for five hundred horses. It was run by T.J. Pendergast's business partner, Phil McCrory. Pendergast was among the top horse breeders in the region. "At Riverside," authors Lawrence Larsen and Nancy Hulston wrote, "Boss Tom, in regal style, and with his son at his side, preferred a box

Milton Morris ran the Saratoga Club at 3504 Troost Avenue. *Author photo*.

in the grandstand at the finish line, disdaining the comfort of the enclosed clubhouse." He was also one of the biggest bettors.

The proprietor of the Saratoga Club was a young man named Milton Morris. In 1931, Morris, then nineteen, had been a clerk at the Raywood Pharmacy at Twenty-Sixth and Troost. His boss was Abe Tuzman. Another man, Sammy Bachman, ran a regular poker game in the drugstore. That summer, Morris and Tuzman were arrested for buying cigars and cigarettes stolen from a Katz drugstore. Tuzman got thirty days in the county jail; Morris a twenty-five-dollar fine. That November, Bachman shot a man dead over what some said was a bootleggers' quarrel. A grand jury failed to indict him.

Early in 1932, Tuzman found himself in the wrong place at the wrong time—in Bachman's company when someone sought revenge for the November killing. Their bullet-pocked bodies were dumped by the side of U.S. Highway 40 in rural Kansas. Later that year, another bootlegger was shot dead on the sidewalk near the Raywood Pharmacy. Police questioned several men who sold liquor retail. The men blamed a powerful bootlegging ring. The Depression, they said, had made liquor sales unprofitable and unsafe. "The big shots are more resentful than ever of any attempt on the part of the smaller dealers to muscle in on the racket," said one man. "It's all a man's life is worth to try to bring liquor in from outside."

One of the men questioned was Milton Morris. At that point, opening a "race results" service probably seemed like the road to good health.

523 West Twelfth Street

The arched entrance to the five-story apartment building at Twelfth and Pennsylvania, opened in 1891 as the Cordova Hotel, shows the tired elegance of nineteenth-century construction mixed with twentieth-century renovation. First advertised as a "modern hotel with first-class service" and "special attention to the entertainment of families," it later became known for its Cordova Pharmacy, raided multiple times for liquor violations.

In May 1923, federal agents arrested a man named John DiSalvo in room 516 here and charged him with selling ten ounces of morphine to a pretty blonde. A former railroad worker, DiSalvo had a North Side grocery at the corner of Fifth and Forest and the necessary political connections to become a well-paid bondsman and real-estate investor. The store brought

Highballs, Spooners & Crooked Dice

The former Cordova Hotel, 523 West Twelfth Street. *Author photo.*

notoriety for its backroom cabaret, a spaghetti, wine, beer and dance joint characterized by the *Post* as "a deluxe affair" patronized by South Siders. Young women were said to be among DiSalvo's best customers, often in the company of gray-haired men.

"It's the woman's fault," DiSalvo said after his arrest. "She told me that if I would get her some drugs she'd be my sweetheart. That's why I did it—not for money, for I wasn't going to sell the dope—just give it to her like she asked me."

The agents claimed the woman sought revenge. DiSalvo, she told them, had made her husband a drug addict and criminal. The Cordova Hotel was the arranged site for a sting.

Narcotics problems were not something new. The number of people nationwide who used drugs for non-medical reasons had been growing since the Civil War. After 1900, a general consensus developed from fear drug use "might retard accepted ideas of progress and civilization," according to author H. Wayne Morgan. "And nonusers in the 'normal' society feared that anyone risked becoming like the black, Mexican, oriental, or Near Easterner if he permitted drug use to detach him from majoritarian values.…The

growing sense that it was a national problem coincided with other forces that pointed toward regulation."

When Prohibition began, the federal Harrison Anti-Narcotic Act was five years old and the basis for prosecution in Kansas City. (Missouri had no narcotics law and would not until 1937.) Agents said more illegal narcotics were distributed here than cities of a similar size. Police records said 90 percent of criminals were addicts served by street peddlers, physicians who wrote fake prescriptions and druggists who filled them. Raids showed the variety of "stuff" long available here: A bootblack selling morphine out of his shoeshine box; a doctor selling cocaine out of his hotel; women in a rooming house, dressed in Chinese silk, lying on embroidered pillows, smoking opium pipes.

Marijuana did not show up here until the 1920s, arriving from Mexico via railroad workers. As early as 1922, Mexican laborers caused alarm in central Kansas by smoking cigarettes they called "Doña Juanitas." In 1928, a dealer was shot dead on the West Side in what police called a sellers' war. Marijuana was not covered under federal law; the city passed an ordinance allowing fines. The first arrest came in 1930. "The weed has a kick stronger than corn whisky," said the arresting officer. "And it is much more dangerous to mortals, besides being habit-forming."

In June 1923, a federal jury convicted John DiSalvo of selling narcotics, and he got seven years in prison and a $1,000 fine. A year later, an appeals court found the judge had disallowed consideration of illegal entrapment and reversed the decision.

30 West Pershing Road

Auto traffic is steady today in the Union Station lot, though not because of train traffic. Amtrak's three arrivals and three departures daily are a pale imitation of the 1920s, when hundreds of trains represented a dozen passenger lines here. Taxicabs queued up in rows curling around what was known as Union Station Plaza, awaiting fares to downtown hotels or destinations suggested by the cabbie.

In 1921, a cab driver named Lloyd White worked a regular route from the station to a joint at Eighteenth and Woodland, promising his clients "a good time." This was the charge police made when they arrested him in a raid there. "Such fellows as you," said the police chief, "who induce persons

to ride your taxicabs to immoral resorts, where often they are robbed and even killed, should be run out of town."

This racket was common. Taxi drivers received a percentage from operators of certain rooming houses for delivering customers, sometimes as much as 25 percent of what a man spent. In 1926, a cabbie picked up a visiting businessman, took him to a series of cabarets, then alerted cohorts so they could roll the guy. That same year, a cabbie was arrested at his home with a load of booze and a list of delivery customers. Another made key rings for bootleg customers, stamped with his cab stand phone number. "I pick up the fellows who want to find liquor or parties looking for sport," said one driver. "I know where they can find either or both." Taxis came to be known as "immoral resorts on wheels."

For other people, cabs were just one part of a larger societal problem: automotive freedom. "The automobile comes in for a distinct contribution to lowering of moral standards," declared the Society for Suppression of Commercialized Vice. "There is no question but that the automobiles are a great source of moral delinquency." A 1921 article in the *Ladies Home Journal*,

Union Station, 30 West Pershing Road. *Author photo.*

titled "Freedom and Our Changing Standards," warned parents, "With the motor car came the road house, the jazz band; restaurant dancing, unrestricted association of sexes, the new fashions."

According to police, the number of cars in Kansas City rose from five thousand in 1910 to eighty thousand in 1928. Officials blamed autos for prisons overcrowded with dope smugglers, sex traders and bootleggers. (Buick roadsters were said to be favored for their roomy storage.) In 1926, after driving a grueling one hundred hours on city streets, a marathon stuntman complained about local motorists. "I found there is lots of late-night driving in Kansas City," he said. "After midnight many intoxicated drivers can be found on the boulevards. I have had drivers cut in on me at fifty miles an hour."

Then there were the "spooners." A letter to the *Star* from a rural Jackson County woman condemned the "wholesale breaking of the seventh commandment" by couples in cars parked along country roads. Farmers protested to the county court, and the sheriff was told to charge offending couples with "immoral conduct on the public highways." Eventually, it became somewhat dangerous to park in remote areas because of roving bandits, who found roadside lovers easy prey.

By the end of Prohibition, employees at Union Station began noticing more parked cars—containing occupants—lingering in the darker reaches of the lot long after the arrivals and departures of trains. A *Journal-Post* headline declared, "Spooners Discover Station Plaza Is Ideal for Parked Car Courting." It was safer than country roads, said the spooners.

Perhaps it was inspirational, as well. A couple of years earlier, a visiting writer had pointed out that the Liberty Memorial, looming on the hill across the street, "is correctly characterized by the profane younger generation in phallic terms which do not admit of reproduction in print."

416 East Fifth Street

As growth and redevelopment breathe new life into the blocks east of the City Market, the painted brick, two-story warehouse on Fifth between Oak and Locust remains relatively quiet. The old corner entrance is boarded over, the upstairs windows empty. There's no indication of its past life as the Amo Café, "a notorious night dive frequented by underworld characters," as the police called it during Prohibition.

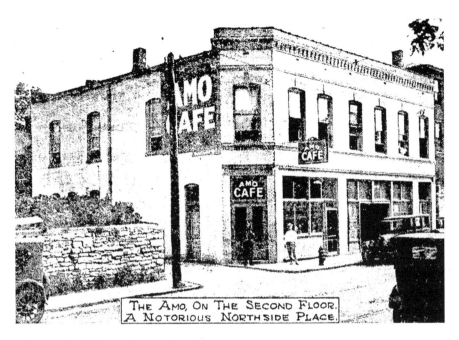

The Amo Café. *From the* Kansas City Star.

The Amo was a second-floor cabaret speakeasy above an auto garage and across the street from the old Jackson County Courthouse. The city directory listed it as the "Italian-American Hall." In 1925, the *Star* called it "one of the most popular all-night cafés on the North Side." Along with El Rigoletto and the Monte Carlo cafés, this place was a regular stop for young South Side nighthawks, who queued up at the door after midnight to down highballs and try out their Charleston moves on some live jazz. They brought flasks; mixers were provided. Pictures of peacocks adorned the walls. A fountain made from a recycled moonshine still featured live, leaping bullfrogs.

Nardo Bivona had been a longtime speakeasy proprietor, first at the Winwood Café at Third and Locust, then here in this building he owned above his garage. His brother Tony was the city's first Italian alderman, which suggests how the Amo survived numerous police raids and a brief padlocking in 1926. After that injunction, the *Star* called it "a sun-dodging business, opening after the sun went down and closing at daybreak" as well as "a playground of the underworld between crimes."

The Amo was linked with violent death. In 1925, a sixteen-year-old boy named Lynn Bouchard rented an automobile for a late-night party-on-

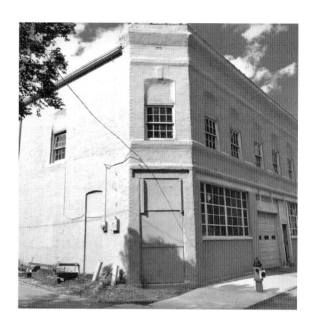

The former Amo Café, East Fifth Street. *Author photo.*

wheels with four friends. Bouchard knew where to find a good time and made stops to buy home-brew, elderberry wine and a half-pint of corn whiskey. About midnight, the party found its way to the Amo and began dancing but were told to stop by management. They left, and Bouchard, enraged and drunk, began driving wildly, whipping the rented Dodge from curb to curb at forty-five miles per hour before slamming into the rear of a parked truck. Three of his friends were killed. He was convicted of manslaughter, driving while intoxicated and delinquency and received four years in the reformatory at Boonville.

In 1928, a businessman was stomped to death in a brawl outside the Amo. Sometime soon thereafter, Bivona shut down the joint.

5907 MAIN STREET

The storefronts at Fifty-Ninth and Main, once known as the Morningside Shops, were built to take advantage of the old Country Club streetcar line. Today, a hair salon and an art gallery occupy space where, in January 1926, a corner drugstore and a shoe-repair shop did business. An Italian immigrant named Joe Spano, who commuted from the North Side, was a cobbler. One day, a high school boy walked into the shop and later walked out with a half-

pint of corn whiskey. Police from the nearby Country Club station arrested Spano for the sale of liquor.

Spano's case came at a time when Kansas City was up in arms about the problem of "flaming youth," a social issue that got its name from a 1923 motion picture about a wild teenage girl. (*How far can a girl go? She smoked cigarettes. She drank. She went to petting parties.*) For years, parents had been warned about new temptations facing the younger generation. "There is too much dancing, too many fussy clothes, too much cigarette smoking and general ennui," one mother told the *Post* in 1920. "I believe it will affect the character of these children and that unless the pace is slackened there will result a deterioration of the race in the next generation. The future of the American stock may be at stake."

In 1925, a high school sophomore girl defended her generation in a speech at her church. "It is true we do not care to do just the things our fathers and mothers did a generation ago; some of these things are not done anymore," she said. "Standards have changed, just as styles have changed. Things that would have been shocking to our mothers in their teens are prosaic and common today."

Police arrested Joe Spano at 5907 Main Street. *Author photo*.

Later that year, young Lynn Bouchard wrecked his car after a drunken cabaret spree, killing three teenage friends. It was the delinquency charge—"growing up in idleness and crime, habitually wandering about the streets in the nighttime without lawful business or occupation, habitually using vile, obscene, vulgar and profane language"—that ignited citywide controversy over "flaming youth."

At Joe Spano's trial in March 1926, the defendant testified that the boy had come into the shop one day with no apparent purpose and noticed the bottle of whiskey. It was for a cold the cobbler had been suffering. When Spano's back was turned, the boy stole the liquor.

The boy told a different story. His name was William Fly Jr., a student at the new Southwest High School. He wore a tie with his Boy Scout uniform, his Eagle Scout badge pinned above his heart. He testified he had gone into the shop to wait for a streetcar and heard Spano quoting prices of corn liquor to a customer. The cobbler offered to sell Fly a half-pint for a dollar. The boy had no money, but Spano gave it to him on credit. He took it to the police station. The police gave him a marked dollar, and two plainclothesmen accompanied him to the shop. Spano, having received a tip that Fly had talked with police, refused the money. The cops arrested him anyway.

On St. Patrick's Day, when the guilty verdict came in, one juror spoke to the press. "That boy, in my opinion, did just what he should have done," said the man, an assistant scoutmaster. "He fulfilled an obligation to God and his country." Spano appealed, lost and did eleven months in the state penitentiary before he was paroled.

In April, author Sinclair Lewis spoke at Burris Jenkins's Linwood Boulevard Christian Church. The topic was flaming youth. The papers the next day focused on Lewis challenging God to strike him dead on the stage, not on his message to parents about their children.

"Give them food, clothes, and tell them the truth," he said.

429 Walnut Street

The two-story Merchants Bank building at the corner of Fifth and Walnut is the sole survivor of its block from the days of the original City Market. Today, a neon sign left behind by another former tenant names a restaurant on the first floor. During Prohibition, another restaurant occupied the basement.

Highballs, Spooners & Crooked Dice

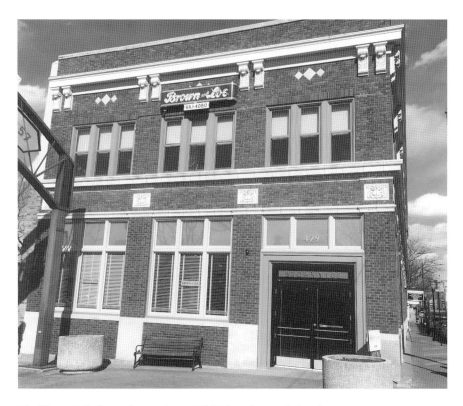

The Pompeii Café was downstairs at 429 Walnut Street. *Author photo*.

The Pompeii Café had been caught with wine and liquor at least once, but several times it ran into trouble for another reason. Just before Christmas 1926, police made an early morning raid and arrested eleven people for violation of a city ordinance that outlawed dancing after 1:30 a.m. Ten patrons were later released when police testified no one was actually dancing when they arrived. The proprietor, however, was fined for operating a dance hall without a permit.

In the 1920s, dancing was great fun or great evil, depending on your perspective. "It is not the dance so much as the way they dance nowadays," said one concerned mother. "Not of a character to preserve morals," said another who saw dangerous eroticism in the Shimmy, Black Bottom, Charleston, Texas Tommy, Camel Walk, Cootie Crawl, Varsity Drag and other new dance steps. A Methodist pastor declared any amusement that allowed a man "the privilege of holding a girl in his embrace during the gallop of the latest dance wiggles is utterly without defense for its existence."

Dance permits were required of cabarets and public halls, and the Board of Public Welfare dispatched dance hall inspectors to enforce the rules, including that ladies keep hands and arms on the gentleman's shoulder, and the curfew was often abused at the Pompeii Café. Fines could be as much as fifty dollars.

Dance halls included the Beetle, a third-floor hall atop the Williamson Building near Twelfth and Central. In 1929, the Beetle charged a nickel to dance to the music of Bill Saunders's Blues Chasers, with one of "75 saucy misses." Themed all-night parties there ("Hat and Cane," "Mahatma Gandhi," "Streets of Paris") featured the saucy misses in revealing costumes.

Newspapers reported dance-hall fights and other dancing-youth-gone-bad stories. Four young men, needing cash to enter dance contests, were jailed for armed robbery; "The Charleston is the cause of us being here," said one. Five young women got six months in the county jail for shoplifting dresses to wear dancing. "Public dance halls are behind the troubles of these girls," said the prosecutor. "They started going to dances to have fun, and acquaintances they made there taught them to steal." A grand jury, finding public halls where youth "as young as 13 are seen on the dance floors," declared that "dances chaperoned by interested parents will eliminate many of the evils."

Undeterred, a group of high school students published a pamphlet advocating for their favorite pastime. "On with the dance," they wrote. "Let joy be unrefined."

1516 East Eighteenth Street

The rooftop neon sign just east of Paseo identifies the Eighteenth and Vine District, once the center of African American commercial life, now a themed development based on a single beloved legacy of the Pendergast era. "The music is all that deserves to be remembered," John Cameron Swayze, a *Journal-Post* reporter of the time, said years later. Now, years later still, the office of the Eighteenth and Vine Jazz District Redevelopment Corporation occupies space that produced some of that memorable music, as well as some of Prohibition's lawlessness.

"Negro Killed in Gambling House Fight." That was the headline on a one-paragraph *Times* article in February 1927 reporting the shooting death of Samson Evans in this place, listed in the city directory as Alvin Jordan's

The former Subway Café, 1516 East Eighteenth Street. *Author photo.*

soft drink parlor and taxi stand. By December 1932, when a federal judge ordered the entire two-story building, including the basement, padlocked for a year for liquor violations, it was the Subway Café.

Jazz players of the day would recall the basement of the Subway fondly, as author Chuck Haddix remembered. "A small casual joint with a low ceiling, the Subway served as a popular gathering spot for musicians

needing a loan, a meal or just a place to hang out and jam," he said. It was managed by "a trim, dashing gambler well-known for his generosity to musicians" by the name of Walter "Piney" Brown.

Jazz had been heard in Kansas City since before the United States entered the war in France, primarily in auditoriums, dance halls and theaters. By 1920, a columnist with the African American weekly *Sun* was praising "the sweet spell, the charm of swinging around on time with the music, stepping to the exact beat of the drum, the plang of the piano, the moan of the saxophone, and, most lately, the exhorting appeal of the singer—all mixed in the frenzy of the exhilarating noise."

By contrast, the mainstream press often cast jazz in a low light, usually in racial terms. A typical article mentioned a "Negro orchestra" in a 1920 speakeasy raid. "They sang with fervor," a *Star* reporter wrote, "bending over their instruments until the black faces were wet and shining." Stories presented experts railing against the new music. A 1922 *Post* article quoted a doctor warning that jazz "is bolshevism in music just as we have bolshevism in politics, art and psychology, and as such it cannot fail to be a bad influence." That same year, the *Star* covered a speech to teachers by the superintendent of schools, who cited a Princeton educator's critique of jazz as "invented by demons for the torture of imbeciles," compared it to "a stiff drink of booze" and wondered whether jazz, too, was worthy of prohibitory legislation.

"The sanctity of the home must be preserved," he said. "And it cannot be done with our youth moving their bodies to the sensuous rhythm of tom-toms and devil-inspiring music."

Jazz came to be a fixture in the most popular speakeasies. And before closing near the end of Prohibition, the Subway Café was the place to be, according to one veteran musician. "All over the world you can hear about Eighteenth and Vine," he remembered years later. "In the middle of the block was the Subway. This was down in the basement. This is where any musician of any consequence, come to Kansas City, well, he'd have to come down there and blow, you know."

5

Yokels and High Rollers

If you were an out-of-town visitor, you probably arrived as most did—by train. Well over two hundred hotels were scattered around town. Working-class travelers might choose from among smaller, less expensive hotels strung along Main just north of Union Station, a stretch then known as "Yokel Row." Years later, a former Nebraska farm boy recalled his first trip to Kansas City, made with his brother, after the corn harvest in the fall of 1926:

> On our arrival at Union Station, we were awed by the great hall in the station ablaze with lights. Outside, we were just a little frightened by the vociferous cries of the taxicab drivers. We clung to our battered suitcase as if it were full of banknotes, and walked downtown to find a hotel. By the time we reached Twelfth street, and had been accosted by no fewer than eighty-seven pimps and prostitutes, Herbert and I knew Kansas City was the biggest, wickedest city we had ever been in.

Whether they realized it or not, the two were poster boys for Yokel Row, a term the *Star* probably coined (the *Journal* favored "Hicks Promenade"), referring to rural innocents preyed upon by unscrupulous hawkers, merchants and hotel proprietors along those blocks of Main. (An original Yokel Row thrived along Union Avenue in the West Bottoms when the train depot was there.) Visitors complained of pickpockets and con men, of being forced off sidewalks by solicitors or hounded into buying something and

being overcharged or short-changed. One victim said he was charged a toll for crossing the viaduct.

As the Nebraskans discovered, Yokel Row also offered vice. The Grapevine Cabaret near Nineteenth, with ads reading, "Dance, dine, be entertained, no cover charge," was raided multiple times for liquor violations. A drugstore at Twentieth Street was busted for selling morphine. The list of "immoral hotels" compiled by the Society for Suppression of Commercialized Vice included some along here.

As an upscale traveler, you might have preferred the downtown hotel district, where the largest and grandest were clustered near the convention center, theaters and department stores. The intersection of Twelfth and Baltimore had a large hotel on each corner: the Dixon; the Glennon, replaced in 1931 by the Phillips; and the city's two largest, the Baltimore and Muehlebach.

"Damon Runyon, who called his characters guys and dolls, would have found plenty of either around Twelfth and Baltimore avenue," a *Times* columnist later recalled. "When there was a lot of action, as the gamblers say, there were many vivid personalities around who would have supplied grist for the fiction mill of the Manhattan, Kansas–born Runyon."

More than a few visitors met a fate similar to that of three conventioneers from New York in 1925. Staying at the Hotel Baltimore, they sought a taste of the local night life. As the next day's *Star* put it, "Two drugstore cowboys shunted them onto some Western moonshine, a car, and a series of chicken dinner farms. There were three girls and a chauffer." They awoke the next afternoon in a different hotel, $600 lighter. Police were able to find the girls.

"Yes, we were with them," said one. "Those boys are all right, but they can't stand the Kansas City speed. They belong back in New York."

2020 Main Street

Just north of Union Station, across the viaduct spanning the railroad tracks, a renovated two-story brick structure built during World War I now faces the twenty-first-century streetcar tracks. In 1925, this was the Otten Hotel, which included a couple of storefronts at street level. One was a mercantile company, the other a restaurant called the Main Street Barbecue. That summer, a federal judge issued a six-month injunction against the restaurant for fifteen liquor violations the previous year. The same judge later fined the

Highballs, Spooners & Crooked Dice

The former Otten Hotel, 2020 Main Street. *Author photo.*

joint's operator, Frank "Swede" Benson, one hundred dollars and sent him to county jail for three months.

Benson was a longtime gambler, speakeasy owner and political operative. A former deputy county marshal, Benson counted votes and cracked heads in elections for Miles Bulger, a Democratic rival of Tom Pendergast. In late 1919, during wartime prohibition, police closed Benson's notorious Leaping Hound cabaret on Summit near Southwest Boulevard (reportedly named by a customer who declared "the booze sold here would make a hound leap at a lion."). His subsequent pool hall, across Summit, was also raided several times for gambling and liquor. Political protection kept him open until Bulger's power faded. By the time the Main Street Barbecue was padlocked, Pendergast was firmly in control.

In March 1926, police raided the Otten Hotel, former home of the Main Street Barbecue. They found more than one hundred cases of rubbing alcohol in the basement, stolen earlier from a warehouse on Holmes by bootleggers for redistilling.

That same day, a small article in the *Star* announced Tom Pendergast would soon be moving his Jackson Democratic Club office from the Gumbel

Building to the second floor of a new building at 1908 Main. "More centrally located quarters with more space was the reason," the article said, without mentioning Yokel Row.

1922 Main Street

The three-story building with the hand-painted advertisement for "J. Rieger & Co. Monogram Whiskey" on its brick flank is staying true to its original function, though in a luxury unimagined when the Rieger Hotel opened in 1915. Its twenty-two rooms with bath and steam heat have given way to a 7,500-square-foot fully furnished vacation rental that sleeps twelve, with two kitchens and a rooftop patio. The once advertised "excellent café" on the ground floor is now a chef-driven grill with a motto of "Beautiful food for the people." Today's dark neo-speakeasy in the basement has no 1915 precedent.

Change began at the Rieger soon after it opened. By 1917, it was called the Lennox Hotel. Then came a sale and another name change, to the

The former Travelers' Hotel, 1922 Main Street. *Author photo.*

Travelers' Hotel. Prohibition arrived, and with it came stories like that of Oliver Fitzpatrick.

In the summer of 1926, Fitzpatrick was an eighty-two-year-old Civil War veteran who lived in the Soldiers' Home in Leavenworth, Kansas. That July, stopping here on the way home from Ohio, carrying $500 cash, he checked into the hotel. The *Star* told it this way: "At the hotel, a Negro porter solicited and sold him a pint of corn liquor, the veteran said. After drinking the liquor, a woman came into his room and this morning the money was gone." Police arrested the night clerk, the porter and a twenty-two-year-old woman. Fitzpatrick's money was never recovered.

This kind of story was common to the hotel then. A drunken man once shot up the hotel bar. Another went from room to room, banging on doors, demanding guests "Do that shimmy dance or I'll shoot!" A cop was dropped from the force for demanding free drinks. The hotel made the anti-vice society's list of places where "a uniformed colored porter solicits customers for his hotel with added attraction of the companionship of 'nice girls.'" The bar was raided, its craps table confiscated, its operator arrested for selling highballs. A porter solicited plainclothes cops, dressed like "yokels," asking if they "wanted to buy a drink."

The owner of the Travelers' Hotel was Floyd Jacobs, who bought it from the Alexander Rieger Investment Company a week before Prohibition began. Jacobs had been a Jackson County prosecutor before the war, responsible for putting Johnny Lazia in prison for first-degree robbery. (He recommended Lazia's parole after eight months of a fifteen-year sentence.) He unsuccessfully ran for Congress in 1928 and had strong connections to the Pendergast machine. Criminal charges that originated in the Travelers' Hotel had a way of evaporating.

The porter who tried to sell liquor to the yokel-cops had Jacobs represent him in court.

"A policeman certainly has mighty little to do these days when he dresses like a farmer and goes around arresting boys who are trying to make an honest living," Jacobs said to the cop who led the raiders after getting the case continued. "They certainly could spend their time better trying to catch some of the city's criminals."

"Yeah?" replied the police sergeant. "Well, when you were prosecutor, you'd have turned all these cases loose."

"When they put a police uniform on you," Jacobs shot back, "they took a good farmer right out of the fields."

1900 Main Street

The windows at the southwest corner of Nineteenth and Main today reveal well-dressed restaurant patrons perhaps enjoying a six-course meal. In late 1925, the view was of cigars, pharmaceuticals and a drugstore proprietor named Matthew P. Clarkin. Three years earlier, the national *Drug Trade Weekly* had carried an announcement that began "Kansas City—Matt Clarkin, for five years a policeman, has decided to forego the exciting life of a cop and enter the drug business. He has resigned from the police force, effective at once."

Between Christmas and New Year's 1925, the store at Nineteenth and Main was raided and Clarkin charged with possession of four quarts of alcohol and released on $1,000 bond.

The son of an Irish immigrant firefighter, Clarkin was a young cop—"the 'ace' of the motorcycle squad," according to the *Post*—in 1921 when he foiled a bank robbery on East Twelfth by shooting two holdup men, killing one and wounding the other. That won him a Distinguished Service Medal. Promoted to detective by 1922, he quit the force that November, apparently having decided drugstores could provide a better living. He partnered first with his brother at Sixteenth and Broadway, then signed a five-year lease on this space.

Clarkin was not the first so-called "good guy" to flaunt the Volstead Act by opening a bootlegging drugstore. Joseph Cusack had been a hardware salesman who organized children's festivals for the Elks Club and a parole officer before the *Star* labeled him a "booze-selling druggist." Cusack opened a series of drugstores in the vicinity of the "brewery district" along Paseo. In 1925, his store at 1201 Paseo was raided by federal agents and padlocked for illegal liquor sales. He escaped prosecution—his clerk paid a fine—probably through membership in Pendergast's Jackson Democratic Club. The *Star* declared the case "a glaring example of weak prohibition enforcement."

Despite Clarkin's police connections (his father-in-law, I.B. Walston, for a time was chief of detectives), he was arrested twice for liquor possession and once for selling corn whiskey to a cop. In each case, he escaped prosecution because of insufficient evidence.

A year after the 1925 arrest, he was running the Ambassador Hotel pharmacy at Thirty-Fifth and Broadway. In 1927, his clerk was arrested. As the *Star* reported, "[T]he report came in that motor cars drove to the curb, tooted a signal, and occupants were served highballs in their cars." Police found four people drinking cocktails behind a prescription case.

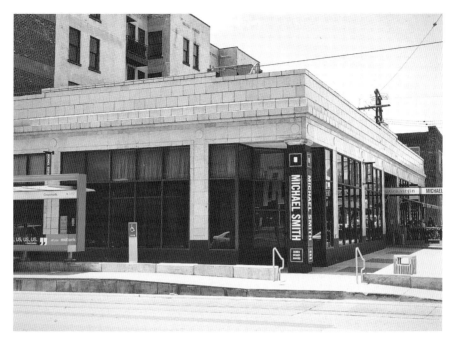

Matt Clarkin's former drugstore, 1900 Main Street. *Author photo.*

Clarkin then made a move to the restaurant business, opening the Dutch Mill Gardens across Broadway from the Ambassador. There he was raided in 1928 and charged with selling spiked beer and alcohol. By the end of Prohibition, he was back on Main, at Thirty-Seventh, using his longtime nickname—a name that would have lasting resonance in local jazz lore—in a place called Tootie's Paradise.

1114 Baltimore Avenue

The thin Gothic-style building rising to ninth-floor double gables is another new piece of downtown's residential rebirth. The apartments are named for one of its past incarnations—the New Yorker hotel—but the brick exterior still wears the original 1915 name in fading paint: Hotel Bray. In February 1930, police received a tip that men with bulging pockets were seen running in and out of a fourth-floor room at the Bray. In the room, cops found two men, two handguns, two quarts of gin, four pints of whiskey and some labels

The former Hotel Bray, 1114 Baltimore Avenue. *Author photo*.

and bottle-capping equipment. The phone rang during the bust. It was the front desk clerk warning that cops were on their way up. He was arrested with the other two.

The Bray was a smaller hotel, just twenty-five feet wide, facing one of the biggest, the block-long Hotel Baltimore. Along the Bray's side of the

Ad for the Hub, 1928. *From the* Kansas City Journal-Post.

street were women's clothiers, a couple of restaurants, a drugstore and cigar shops. By the end of Prohibition, there were two new high-rise bookends at the corners: the Hotel Phillips at Twelfth, which replaced the Glennon, and the Fairfax Building, which replaced one of the city's most notorious gambling joints, the Hub café and pool hall.

Next door, a Chinese restaurant occupied the first floor of what had been the Mansion Hotel. Just before Prohibition, the second floor of the Mansion had been what the Hub later became. Guests at the Hotel Baltimore across the street could see the card game in progress and the bar, roulette wheel, blackjack and craps tables run by a Pendergast lieutenant. If they complained, cops would say they'd check into it, and the Mansion's window shades soon would be drawn. When the Chinese restaurant closed, Johnny Lazia opened another gambling joint here called the Annex.

By 1928, the Hub had grown from a small basement operation to the largest game in town, with dice, poker, blackjack and race betting. Run by Arthur "Toad" Rayen, brother of a policeman, the Hub had lookouts and a buzzer warning system, and guns were checked at the door. None of that prevented a half-dozen armed robbers from fatally shooting a doorman, wounding two others and stealing $1,500 from patrons one night in May that year. The same night, a gambler who had suffered big losses at the Hub and other joints shot himself dead. Police vowed to "close up the town," but the Hub was back in business in time for the Republican National Convention in June.

The Hotel Baltimore was headquarters for delegates supporting Herbert Hoover, the eventual 1928 GOP nominee. Seven years earlier, the hotel had welcomed the raucous American Legion convention, when Allied war generals dedicated the Liberty Memorial site. On the final night, the lobby was the scene of a shootout between police and revelers. No arrests were made, and the next day the *Post* summed up: "Liquor had flowed like water during the three nights of the convention. Crap games were in progress in the lobby of the Baltimore, and the length of Eleventh street every night.

Bottles of 'white mule' and 'moonshine' were set up in the center of each group of crap shooters."

For the Republicans in 1928, the police chief and federal agents had promised to crack down on the city's estimated two hundred speakeasies. "Not only do we want to close up Kansas City and have it respectable for the convention crowds," said the chief, "but we want to keep it respectable afterward." Agents working a month in advance managed to get temporary injunctions and padlocks on several drugstores and soft drink parlors.

A Washington political columnist, writing from Kansas City, noted that "just before the convention twenty or thirty brand new speakeasies were opened up, a few of them quite fancy places with booths, music and other frills." He assured his readers that "one can see one's favorite bars from the sidewalk or the hotel corridor in some cases, so that the delegate from Chicago, New York, or Atlantic City feels perfectly at home."

100 West Twelfth Street

When the Hotel Phillips opened in 1931, it brought streamlined chic to the district with its polished black-glass ceilings, walnut paneling and bronze *Goddess of Dawn* by sculptor Jorgen Dreyer. The people who run the Phillips today call it "an iconic hotel with an illustrious past." In the early 1930s, it was "Just a Step from Everything," with radio, electric fans and circulating ice water. Where today's hotel restaurant presents "Farm to Table Authentic Italian Dining" at the corner of Twelfth and Baltimore, the Katz drugstore No. 7 once dispensed aspirin, prescription liquor and an illegal chance to test your luck.

In September 1932, someone telephoned the county prosecutor to remind him of his campaign promise to make arrests whenever he found slot machines in operation. Well, the caller said, there were slot machines at Katz drugstore No. 7. The prosecutor visited, watched a customer play a nickel slot near the cigar counter, found a dime slot under repair on the balcony and arrested the assistant manager.

Slots had been in Kansas City since well before the beginning of Prohibition and were outlawed by state law and city ordinance as gambling devices. Over years and many raids, hundreds were confiscated and destroyed. Yet in 1932, an estimated two thousand of them remained in drugstores, pool halls, restaurants and speakeasies throughout the city. They

The former Katz drugstore No. 7, 100 West Twelfth Street. *Author photo*.

were the tabletop type, accepting pennies, nickels, dimes, and quarters and paying off—or not—in coins, mints or tokens for merchandise. Racketeers controlled distribution, installing the machines, promising police protection or legal aid and providing a cut of the take. It was said most machines made at least one hundred dollars weekly.

But their presence near schools brought constant criticism. The *Star* called slots "the most vicious form of gambling" because children played them. "These devices are a contributor to juvenile delinquency," said the mayor. "School children, boys and girls, operate them without hindrance in the residential districts, I am told." The police chief declared the cops were trying to keep them out of the city, but "we find them creeping back now and then in mushroom fashion."

In 1932, the prosecutor declared his war on slots. Cops confiscated machines and, as ordered by Henry McElroy, Pendergast's handpicked city manager who had gained control of the police department, put the axe to them. McElroy called it an effective punishment, as loss of a machine cost owners more than fines. The prosecutor protested the destruction of

evidence. Finally, someone decided slots should be confined to speakeasies and removed from legitimate businesses. "Such are the orders, it is understood, that have gone down the line," the *Times* reported.

Slots did not disappear from legitimate businesses, partly because they were quite popular. "I will not remove them from small independent stores," McElroy said in 1933. "Why? Because they are keeping small, independent stores in business. I am not going to force the owners of those stores to close and walk the streets looking for work."

He added that he didn't believe slots corrupted children—parents did. "Any child who must be reared by the police probably will turn out to be a police character," he said.

1210 Baltimore Avenue

The ornate iron-and-marble-framed doorway south of the Baltimore entrance to the old Muehlebach Hotel (now part of the Downtown Marriott) has a revolving door that stays locked. The room inside—known in 1920 as the Muehlebach Hotel Bar—remains a time-warp of wood-paneled elegance, rarely used.

The Muehlebach and the Baltimore, both then run by the same company, received their share of attention from federal Prohibition agents. Raids at the hotels' supper clubs—the Muehlebach's Plantation Grill and the Baltimore's Pompeiian Room—usually found guests mixing highballs from flasks or half-pints of liquor.

Back then, this bar would have been an ideal spot to order a C&G Mulo (a Muehlebach near-beer) and watch street life: theatergoers queuing up next door at the Orpheum, a vaudeville palace designed after the Paris Opera House; burlesque fans heading the opposite direction to the Gayety Theater at Twelfth and Wyandotte; men with pool cues at Kling & Allen, on the second floor of the Hotel Dixon; prominent businessmen bound for the Kansas City Club at Thirteenth; bowlegged cowpokes, up from the stockyards for a little fun; or even a wayward steer, as in 1928, when a trainload derailed in the yards, the terrified animals scattered and one was corralled and tied to a lamppost here.

Another common sight outside these windows had to do with the neighborhood industry, as described years later by a *Times* reporter of the day:

The Muehlebach Hotel Bar was at 1210 Baltimore Avenue. *Author photo.*

The old Muehlebach bar today. *Author photo.*

Prohibition in Kansas City, Missouri

Like a hatch of flies, stickmen and dealers in their fresh white shirts, their tidy little green aprons, had swarmed from the street's gambling tables and eddied around the street for their cigarette break.... The pedestrian traffic suddenly thickened: the hard books had let the town army of handicappers out of class until the first post call at Hialeah the next day.

In 1921, the *Post* reported, prominent gamblers established a "clearinghouse" office in a joint near Twelfth and Baltimore, where players could sign a register indicating the type of game they were seeking. When enough prospects had registered, they were sent to a room in one of "two large downtown hotels," where the game—safe from police interference—would be run by one of the "magnates of the green cloth and lowered blinds." Among magnates identified were Lawrence Maxey and George Bandel.

Bandel, sometimes called "Beau Brummel," was characterized in the *Times* as "a true disciple of the god of chance," said to have won and lost several fortunes over the years. Craps was his game, but he also played the horses. He dressed impeccably, spoke in an affected manner and carried a large wad of money, which led to his reputation as "the most frequently held-up man in Kansas City." Several times, stick-up men relieved him of thousands of dollars. Once, robbers crashed a game, shouting, "Which one is George Bandel?"

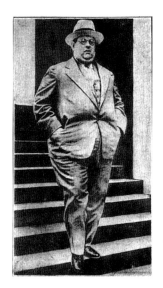

Solly Weissman, the morning he was shot in 1930. *From the Kansas City Journal-Post.*

Maxey was known as "Gold Tooth" for some flashy dental work. The *Post* called him the city's "dice gambler deluxe," but the police chief knew him as "a notorious gambler and a menace to the young men of the city." Once charged with vagrancy, Maxey won his freedom in court by contending that a man worth $25,000 could not be considered a vagrant. The clearinghouse office was probably his Twelfth Street basement joint between Baltimore and Wyandotte.

For a time, Felix Payne was also a neighborhood presence. Payne was a prominent African American businessman and Pendergast associate known to the *Star* as "a notorious gambler" who owned the Waiters & Porters Information Bureau—essentially a gambling

club—at 1219 Baltimore. Payne had similar clubs at Twelfth and Highland and elsewhere and ran several policy wheels—illegal lotteries.

Opposite the Muehlebach bar, in the Hotel Dixon building, a street-level cigar store first known as the Crescent, later as the Turf, drew horse players. Run by Arthur "Toad" Rayen, who previously managed the notorious Hub pool hall, the Turf became infamous when gangster Solly Weissman was fatally shot here one day in 1930 by the operator of a racing information service. Weissman had threatened the man, who refused to provide racing results before they were announced.

In the basement of the Dixon was Baltimore Recreation, also frequented by racing fans. "This is the way I like to bet," said a musician at the Muehlebach who patronized the place. "Point at the wall and someone whips your money away from you to put on the horse you bet on. You generally don't get the money back, but that's your fault. You ought to pick horses better."

It's a safe bet that some among the Hotel and Restaurant Employees International Alliance gambled a bit when they convened at the Muehlebach in 1929. At least one member of a small subgroup, the Bartenders International League, was able to find satisfaction elsewhere.

"There ain't no Prohibition, there never has been and never will be," he declared. "I was drunk twice yesterday right here in Kansas City."

1228 Baltimore Avenue

Today, the soaring spaces inside the high-rise Gothic building at the northwest corner of Thirteenth and Baltimore can be rented for weddings, conferences and other events. In 1921, as the soon-to-be-completed new home of the Kansas City Club, it was being called "one of the greatest business assets in the Southwest." By 1926, South Side high school students were driving up to this east entrance, tooting a horn signal, "and out would come a Negro doorman," as the *Star* reported. "Pay him the money and you got the liquor—good, bonded liquor."

The Kansas City Club had been, in various locations since 1882, a place for businessmen and professionals to network and socialize. When this fourteen-story home opened with a dinner dance in May 1922, 1,500 guests attended. The *Star* had already reported on its amenities, including "private dining rooms, billiard rooms, card rooms and grill, a tile swimming pool, two-story gymnasium, handball courts, Turkish baths, men's and women's

Prohibition in Kansas City, Missouri

The former Kansas City Club, 1228 Baltimore Avenue. *Author photo.*

lockers, and physical directors' rooms. Then six full floors of bedrooms and living rooms for resident and non-resident members or their guests."

But this was a "good-ole-gentleman's club" of back-slappers and cigar smokers and poker players, where being prominent and respected didn't necessarily mean abiding by the rules. The membership included one Thomas J. Pendergast, beverage distributor, as well as a young county judge handpicked by Boss Tom, Harry Truman. According to a biographer, "Truman paid $225 to join the Kansas City Club in the summer of 1919 so he could circulate in the upper-level business community. The Kansas City Club provided an atmosphere of sexism, racism, and anti-Semitism that the town's ruling elite found congenial for important business and civic discussions."

Many large companies worked with Pendergast in exchange for tax breaks or government contracts. As Truman's biographer noted, Boss Tom proved his organization could help large corporations make more money, and in turn, those businessmen for a time tolerated his abuses.

Bootleggers' best customers were chamber of commerce types, captains of industry and other well-to-do people, including many South Side residents.

Aspiring reformers were constantly lecturing otherwise lawful business leaders. "Every time you buy liquor from a bootlegger you are helping the underworld," one speaker told the Rotary Club in 1932. "Every time you park beside a fire plug and ask to be relieved of reporting on the ticket you are helping the political bosses. This hookup with the underworld is caused by the upperworld."

In 1923, police received a tip that liquor from Canada was being delivered to the Kansas City Club in two Cadillacs with out-of-state license plates. A cop spied such a car parked outside the club. "Just make a delivery?" he asked a man carrying an empty trunk. The man smiled, was arrested and his bond was paid by a downtown lawyer.

In 1925, federal agents found more than one hundred quarts of whiskey in two rented suites on the eleventh floor of the club. "We have suspected for some time that liquors have been peddled from certain rooms in the club to various residential hotels," said an agent. Two club members—company CEOs—were charged with liquor violations. Pleading guilty, each was fined $300.

The next year, as the city fretted about flaming youth, the booze curb-service to students was discovered. The club president said he was sure his African American doorman could not have been selling to club members, "because he was not allowed to enter the building except to change clothes in the basement." The doorman confessed he was getting the liquor from a parking garage across the street. He got three months on the county rock pile.

6

LET US DARE TO DO OUR DUTY

As a citizen, you were on the mind of the widely respected police expert when he made his efficiency study. "Kansas City has one of the worst police departments, possibly the worst, of any large city in the United States," he declared in 1931. "But its status is not a matter of state control or lack of home rule. Neither is it the fault of the police department. It is the fault of the people of Kansas City."

Citizens seemed to tolerate the fact the police department was subject to the whims of politics. "Any time a city fails to protect its police from politicians,' he said, "it cannot expect adequate protection from the police."

For most of Prohibition, Kansas City's police department was overseen by commissioners appointed by the Missouri governor. From 1921 through 1932, governors were Republicans, not part of the Pendergast Democratic machine. That didn't mean commissioners were above political favoritism or looking the other way on liquor and vice violations. "When men take political office they are determined to look straight ahead," said one commissioner upon his retirement. "But it must be remembered politics has the human factor as its principal equation."

Commissioners named eight police chiefs between 1920 and 1932, the year the machine won a state supreme court ruling allowing "home rule" of the police department. For the next seven years, the machine, not the state, would control the police.

Federal agents were the other primary liquor-law enforcers in town. Agents conducted large-scale raids to shut down joints. But police also staged periodic "cleanups" to rid the city of criminals, vice, and booze.

In 1921, police tried to preempt crime by raiding "questionable soft drink places, pool halls, and alleged gambling and immoral resorts," as the *Journal* reported, and rounding up familiar police characters and "men who do not work and do not intend to work." After one such dragnet, a police commissioner issued a warning to those arrested. "This has to be done every so often so that we may minimize crime," he said. "Mend your ways. Go to work or get out of the city. We do not intend to have any loiterers here." The effect appeared to be minimal.

Often, raids came just before elections, preceded by an administrative order to "clean up this town and keep it clean" and followed by *Star* headlines like "Smile Fades from Twelfth Street" (1921) and "A '9 O'Clock Town Now" (1928) and "So Night Life Folds Up" (1932).

It never stayed folded for long.

207 Southwest Boulevard

The wedge-shaped building at the corner of Twentieth and Southwest Boulevard has been a well-known Mexican restaurant for decades. During Prohibition, this was a soft drink saloon owned by John W. Cleeton, a Republican committeeman serving the second ward, which extended from Fourteenth to Twenty-Fourth and from Grand to the state line.

In the 1920s, Cleeton owned a series of joints along the boulevard, all raided at one time or another. The first was this place, and he avoided conviction at least once by proving he hadn't sold the liquor himself.

Politics and liquor had mixed, of course, since Kansas City's early days. The Pendergast machine got its start in the nineteenth-century saloons of the West Bottoms, where whiskey and free lunches were parlayed into voter loyalty. Both Republicans and Democrats took advantage of this patronage system to gain and maintain political power. Even—or maybe especially—during Prohibition, liquor lubricated the machine. Politicians and liquor continued to mix well.

Take William Lafferty, sixteen years a Democratic member of the Missouri House of Representatives and a Pendergast man. He lived in Cleeton's West Side ward at Twenty-Fourth and Jarboe. In 1925, six months after his first election, neighborhood complaints caused police to raid Lafferty's house. "This place is a well-known home brew joint, and is frequented by persons of questionable character," said the police, confiscating over one

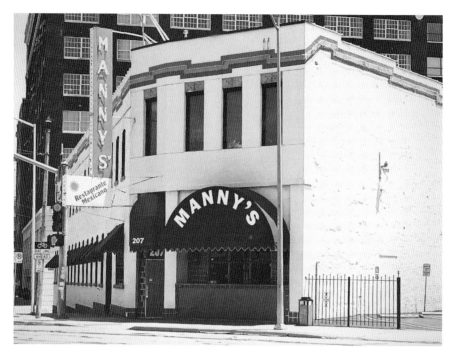

Cleeton's former speakeasy, 207 Southwest Boulevard. *Author photo*.

hundred bottles of beer. "I had the stuff for my own use," said Lafferty. "Any friends who dropped in were welcome to a bottle, but they never paid for it." It wasn't the first such raid; a year earlier, seventy bottles were found. No charges were filed either time.

By 1929, Lafferty was a leader of the anti-Prohibition contingent in the legislature. As such, he authored a bill to repeal the state "bone-dry" law that carried stricter penalties than the Volstead Act. It failed. Before national repeal, he tried twice more without success.

"I still contend if legislators would vote as they drink such a bill would pass," he said.

315 Cherry Street

The little two-story building at Fourth and Cherry today houses a Vietnamese restaurant, one of several in the old North Side neighborhood. Its view to the west—once of a row of Italian homes, and later a small

public park—is now blocked by the monolithic concrete approach to the Heart of America bridge. Even before Prohibition, this was Tony's Place, the saloon of Antonio Barelli. He had emigrated from Italy in 1906 and lived in one of the houses across the street when he married his sixteen-year-old bride, Jennie, ten years later.

Like many saloons, Tony's Place became a so-called soft drink parlor in 1920. In 1926, after five police raids, Barelli was convicted in state court of possession of alcohol and sentenced to a year in jail. Tony's Place was padlocked, but his conviction was reversed a year later by the state supreme court.

One of the long-standing stories still told in the Barelli family is about Harry Truman. Truman was elected county judge in 1922, defeated in 1924,

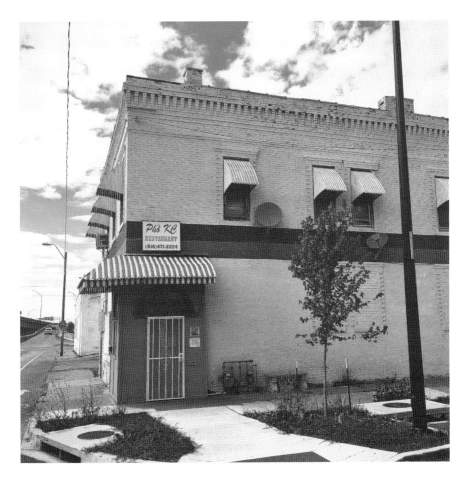

The former Tony's Place, 315 Cherry Street. *Author photo*.

then returned to office in 1926. According to his biographers, his attitudes toward vice were mixed. "He disliked cigarettes, gin, fad diets," noted David McCullough.

> *He strongly disapproved of women smoking or drinking, even of men taking a drink if women were present....He disliked the very sound of the Jazz Age, including what became known as Kansas City jazz....He never learned to dance....Any man who was dissolute with women, Truman believed, was not a man to be trusted entirely.*

Another author, Richard Lawrence Miller, added that Truman took part in the county's crackdowns on chicken dinner farms and on "spooning" motorists who made love along the rural back roads. The roadhouse crusade, according to Miller, alienated voters. As for the spooners, "Critics could scarcely believe county money was being spent on this."

Later, writing privately and musing about his connections to the Pendergast machine, Truman wondered "who was worth more in the sight of the Lord, Pendergast or the "sniveling church members who weep on Sunday, play with whores on Monday, drink on Tuesday, sell out to the Boss on Wednesday, repent on Friday and start over on Sunday?"

And yet, the judge was not completely averse to breaking a few laws, apparently. He was said to have enjoyed low-stakes, back-room poker with friends. "The game had a 10-cent limit," McCullough writes. "A little beer or bourbon was consumed, Prohibition notwithstanding."

After his 1926 election, Truman split his time between the county's two courthouses in Independence and Kansas City. The story told in the Barelli family is that, on his way to work at the courthouse at Fifth and Oak, about a three-block walk from Tony's Place, Truman often stopped in for a bracer, Prohibition notwithstanding.

1519 Main Street

It's a homely little structure on the downtown streetcar line, vacant as of this writing, awaiting renovation or demolition. In the late 1920s, this was the soft drink saloon of Charles Conradt. The son of German immigrants, Conradt had a succession of joints in the vicinity of Sixteenth and Main. In 1921, when his place was at 2 West Sixteenth, he employed

Conradt's saloon was at 1519 Main Street. *Author photo.*

a man to work the street for thirsty customers. One day, a pair of solicited customers drank two rounds of whiskey and then revealed themselves to be plainclothes cops. Conradt went free when his bartender vouched for his innocence.

His saloon had moved to this building by 1929, when two policemen in uniform walked in one day. "There were about fourteen men in the place," one cop later told a reporter. "The Negro porter dumped the whisky." The cop admitted he swore at the patrons as he lined them up for the ride to headquarters. One man approached with a business card from a law firm and suggested the policeman could lose his job. "I told him to get over in line with the other 'big shots,'" the cop said. "Conradt's place long has been a bootleg place. Conradt has made boasts that he had 'big shots' behind him."

The man with the business card turned out to be a former assistant prosecutor. "Other officers told me that it would be better for me not to raid the place," the cop said after being fired.

Prohibition in Kansas City, Missouri

"Higher-Ups Bind Police," read a 1920 *Times* headline. It had been a longstanding reality, as police often kept an eye on saloons for vice activity. Payoffs were common—so was political influence. The *Times* quoted an unnamed cop:

> *A patrolman's job isn't worth a penny if he fails to comply with the demands of a politician or his superior officer. In the old days a patrolman usually had five or six cabarets in his district. Every night he would go to each one of these cabarets and loiter. The proprietor did not like his presence and would tell him his customers were afraid to frequent his place with the officer around. The patrolman would remark he wasn't working for nothin'. Usually the proprietor would give him five or six dollars to stay away. Every night the patrolmen would collect from forty to sixty dollars this way. Now, however, things have changed. If a patrolman hangs around a certain dive and the proprietor doesn't like it, in a day or so the patrolman is told by his superior officer to stay away from it.*

In 1920, a cop's starting salary was ninety dollars a month, with a twenty-five-dollar raise after six months. He had to buy his uniform and equipment. "It's hard to get an honest man for ninety dollars a month," said the chief of police. The illegal liquor industry tempted underpaid patrolmen. "Police accept the money from the still owners, dive keepers and associated persons for protection," said the prosecutor in 1927. "And when the murderer, burglar, or setter of fires and other criminals gets into trouble, then what happens? Well, he goes to the still owner or dive keeper who has been paying for protection, and that person in turn goes to the police department he has been paying and says it must lay off."

In one sensational 1928 case, a woman took an axe and broke up a soft drink saloon at Thirty-First and Holmes. "I guess they won't sell any more liquor to my daughter or husband," she said. A Baptist minister in the neighborhood stirred the pot with his letter to the *Star*, reporting that uniformed policemen frequented the joint, sometimes staying several hours. A cop had been seen delivering liquor to the place.

A police commissioner responded calmly. "Undoubtedly there are men on the department who are winking at liquor and other violations," he said. "Where you have seven hundred men you cannot entirely avoid such things." A grand jury failed to indict any policemen.

The next year, commissioners hired a national expert to evaluate the department. Aptitude was one problem; 58 percent of the cops failed an

intelligence test. The other was politics. "When the police head must bend like a willow to every political breeze," he said, "he cannot control his department as he should."

1311 East Thirteenth Street

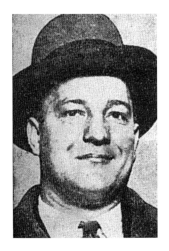

Speedy Stephens. *From the Kansas City Journal-Post.*

The character of Thirteenth just west of Paseo has long included low-level industry. Today it's copper tubing, coaxial cable and floor-cleaning machines. In the 1920s, it was a steam laundry, a towel supply, a metal works. What's missing today is residential life. Gone are the houses and flats that once dominated this African American neighborhood. An electronics company has replaced a church; a plumbing supply stands in for the W.W. Yates elementary school. One old two-story building at the corner of Virginia survives, its windows boarded up, its blank stucco façade giving no hint of purpose. In 1931, this was a much-raided speakeasy.

Police had not gained evidence of liquor here, but that August, two cops tried again. Unable to get inside, they spied a young black man carrying a guitar and offered him fifteen cents to play a popular song of the day, "Springtime in the Rockies," while they sang along. The idea was to imitate drunks who just wanted to get a little drunker. He complied, they warbled, the door opened, and the cops found a pint of alcohol, enough to arrest a man and woman.

One of the cops was George Rayen, a longtime member of the axe squad whose name turned up in stories of joints losing their mahogany bars, mirrors, iceboxes, tables, chairs and liquid refreshments. He was the younger brother of Arthur "Toad" Rayen, the proprietor of notorious gambling dens around Twelfth and Baltimore.

Other individual policemen were notable for reasons heroic, criminal or sometimes both. Matthew Clarkin was a decorated cop turned bootlegging drugstore proprietor. His motorcycling comrade Anton Mouritsen earned fame for single-handedly nabbing three would-be bandits, saving a woman

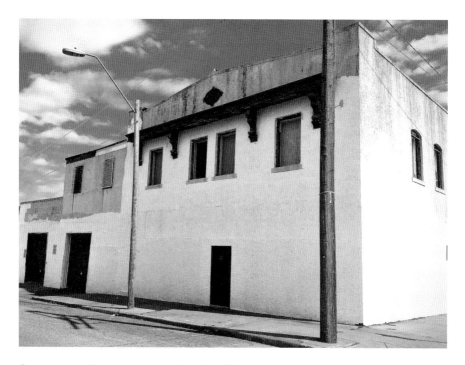

Cops sang outside a speakeasy at 1311 East Thirteenth Street. *Author photo.*

and children in a runaway auto, foiling an extortion plot and winning citations for "conspicuous and meritorious service."

Mouritsen's most sensational case involved a "school of vice" in which a ring of men threw parties that included liquor, drugs, homosexuality and high school students. Some of the suspects were said to be prominent businessmen. Acting on his own, Mouritsen pursued two of them to Chicago and brought them back to face charges. The next year, he was kidnapped by five men, tied to a tree in Swope Park and beaten. A cross was cut into his forehead. "I don't think the attack was because of a grudge for my police activities," he said later, blaming Ku Klux Klan members of the police department because he had spoken ill of the Klan. He quit the force early in 1923 after learning charges against the two men in the vice case had been dismissed secretly. Two years later, he entered the hospital for alcohol poisoning, saying he drank bad wine at John DiSalvo's joint.

Burt Lovejoy was a cop who went missing in February 1925 along with a former policeman named George Peters. Tips led investigators deep into the East Bottoms jungles, thick with willows and mud and squatters' shacks, immigrant truck farms and moonshine stills where armed lookouts

perched in tall cottonwoods. It developed that Lovejoy and Peters had posed as federal agents to confiscate a cache of corn whiskey buried near a still. The two then sold the liquor as bootleggers. Returning for more, they disappeared. Their burned and mutilated bodies were exhumed from the same ground that hid the booze.

Irvin Stephens was a former construction worker and wartime conscientious objector who joined the force in 1922. Early on, Twelfth Street thugs roughed him up in a sort of rookie hazing, stole his badge and gun and ridiculed him. He responded by following them, recovering his gun and shooting two in the legs. Acquiring the nickname "Speedy," he carried calling cards with an Abe Lincoln quote he had seen on a courthouse: "Let us have faith that right is might, and in that faith let us DARE to do our DUTY."

Stephens's record included two fatal shootings of bandits, multiple accidental shootings of bystanders, several reprimands for brutality (a fellow detective charged he used a rubber hose to obtain a confession) and a Distinguished Service Medal "in recognition of his excellent record." His main informers were said to be the Ash brothers, and he was the source of their drug habit. Stephens would raid their mother's bawdy house, haul the brothers to jail and deprive them of narcotics until they talked. He worked mostly alone, sometimes with a German shepherd, carried several guns, prowled the streets all night and was said to be "one of the most feared members of the department." He rose to detective but was demoted after beating a man who reportedly "made remarks about his character."

In 1928, Stephens, who was married, took up with a nineteen-year-old waitress. He set her up in an apartment where she could sell whiskey and run crap games. He beat her, got her pregnant, then refused to care for her and the child. She evaded him for weeks, but he stalked and found her. That was her story after calling an ambulance to the apartment on Paseo. "Come and get Speedy," she said. "I've just shot him. There was no other way to get rid of him." A grand jury refused to indict her for murder.

Years later, a fellow officer recalled Stephens as "a good cop in every sense," and "a man who didn't take any nonsense off anybody."

Of the eight police chiefs who served during Prohibition (before home rule took effect), John A. Miles deserves mention for a string of futile raids on the East Side Musicians Club, an African American establishment near Twelfth and Highland. Miles had been Jackson County sheriff (who worked with Judge Harry Truman to crack down on "spooners" and chicken dinner farms) when he became chief in 1929. Believing the club to be a gambling

joint, Miles ordered more than 100 raids on the place. Each time, charges were dropped for lack of evidence, possibly because of the political influence of Felix Payne, a top Pendergast associate. After the 101st raid, which caught up the cast of the traveling Broadway musical *Porgy*, a wagonload of cast members and musicians pulled up outside police headquarters with a sign that read "We, the members of the East Side Musicians club, ask only for our civil rights of protection and justice guaranteed us by the U.S.A." Then, they serenaded the chief with "I Can't Give You Anything but Love, Baby."

103 West Nineteenth Street

The angular two-story stucco structure near Nineteenth and Baltimore, the property of creative professionals, is today called the Hemingway Building. During a brief moment in its history, Ernest Hemingway spent time there as a *Star* reporter before heading off to World War I. It was then known as Police Station No. 4, or the Nineteenth Street station. The second floor housed the South Side municipal court. Those walls, among survivors citywide, might have the richest array of Prohibition-era stories to tell.

This was a place of one-stop service: speakeasy raids originated downstairs, and bootleggers came to justice upstairs. It was where, in 1925, more than four hundred men were booked downstairs as vagrants (for attending an allegedly "indecent" performance by two dancers named Princess Zaleeta and Little Seaweed) and, the next day, lectured by a judge upstairs ("It's time we were getting back to the old-fashioned rules of decency and morality. If all men showed the kind of sloppy spinelessness you did, what would become of this old world?").

In 1921, cops from this station, dressed as farmers, went to Yokel Row and stared wide-mouthed at a streetcar and a four-story building to attract attention. After a cabbie picked them up, delivered them to a speakeasy and promised, "You can get stuff in here that would make a Missouri mule stand on his ears," the joint was raided and axed.

A 1929 raid at Twentieth and Madison netted more than seven hundred gallons of alcohol that was then stored in the basement of Station No. 4. It was said cops on duty the next morning each received a bottle bonus before the rest was hauled off to an undisclosed destination.

The station had a mascot, a collie pup named Sergeant Bear who rode in a patrol car. Making the rounds in 1926, the car passed a man carrying a

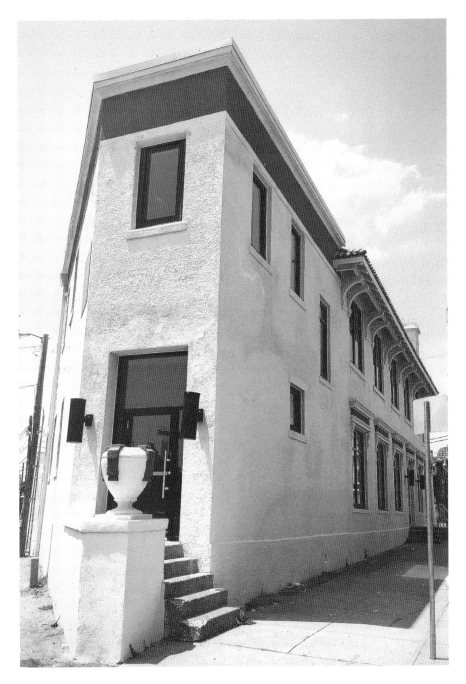

The former Police Station No. 4, 103 West Nineteenth Street. *Author photo*.

gunnysack over his shoulder. Sergeant Bear barked. His partners tracked the man into a house and discovered a fifty-gallon still, then rewarded Sergeant Bear with a pound of hamburger.

Station No. 4 was one of several satellites of the police headquarters at Fourth and Main, adjacent to city hall and the North Side municipal court. Just before Prohibition, a raid from here on one of several gambling dens at Twelfth and Baltimore brought a change in north–south police court jurisdictions and the territories of Democratic factions. Twelfth Street had been the dividing line; Pendergast's "goats" controlled vice dens north of Twelfth, and rival "rabbit" joints were south. After the raid, commissioners moved the boundary to Thirteenth, claiming the new line would "cause less confusion among officers."

The South Side court had three judges during Prohibition. The first, Edward Fleming, a Democrat, got caught in a controversy of his own making when the car he was driving rolled into a ditch, overturned and killed a female passenger. Fleming and three others had been out late at the Edgewood chicken dinner farm on Prospect. He denied drinking and testified that if he tried to hide his license tags or left the scene of the accident or made up a false alibi, he couldn't remember. He was acquitted.

City hall, Fourth and Main Streets. *Author photo.*

Fleming was replaced in 1926 by Ira Gardner, a Republican, elected at-large in 1924 but assigned to the South Side court when the new city charter—and new Democratic majority on the city council—again shifted the jurisdictional boundaries so that most police cases would go to the machine-friendly North Side court. "The old boundary lines were colored more than they should have been with partisanship," said Gardner. "The new ones are worse."

The North Side court was best characterized by Judge Michael Kilroy, a Pendergast minion sometimes called a "friend of the cabaret" for his leniency in liquor cases. Kilroy was often attacked for accepting the word of a defendant over that of a cop. He once discharged race bettors by ruling no horses or racetrack were in the room where they were arrested.

Gardner, succeeded by Carlin Smith in a 1930 Democratic sweep, developed a reputation for tough, provocative statements from the bench. "I'm going to see if I can't get you returned to Italy, where you can make booze to your heart's content," he told a bootlegger. He once suggested a municipal whipping post would solve some problems. "My advice is to shoot the known criminal when they were caught red handed," he said in another case. "That of course is contrary to police instruction, but it would be effective."

1016 West Twenty-Fourth Street

The well-worn blocks of Twenty-Fourth west of Southwest Boulevard contain a hodgepodge of small businesses ranging from a hair salon to a metal works, a recording studio and a print shop. Autos are repaired in a garage near the corner of Jarboe, downstairs from the early 1920s courtroom of Edward J. McMahon, justice of the peace. "A Happy Day for Booze," declared a *Star* headline early in 1924, over a story about a day in the business of McMahon's court. Ten liquor cases were listed. "When the court adjourned shortly after 11 o'clock," the article said, "soft drink proprietors, friends and spectators grinned, for on the court docket ten acquittals were written."

McMahon was closely aligned with Pendergast and, despite no legal training, was named justice of the peace in 1911. A *Star* reporter once spent several days in his courtroom, mostly documenting his apparent willingness to accept a range of explanations: *Not my liquor; Didn't know it was there; Didn't know it was spiked; Not the owner, I just bartend there; Don't know anything about it.* For

McMahon's justice court was at 1016 West Twenty-Fourth Street. *Author photo.*

each, McMahon gave one response: Discharged. In one exception, a man admitted the liquor was his and got thirty days in jail.

McMahon was not alone in his lenient ways, and the court system was seen as a problem for various reasons, including the many continuances handed out, often at the request of bondsmen. A 1923 grand jury called unregulated bondsmen "a menace to society and an obstruction to enforcement of law." These were men with the money to get raid victims released, charging a percentage. According to an anonymous cop in 1920:

> *If the prisoners had political friends or money, the case would be "taken under advisement" by the justice. That would be the last you ever heard of it. If the case was so serious as to attract the public's attention, it would be continued so often that it would be forgotten. Then some day you would hear of it being dismissed because of a lack of prosecution.*

After one of its reports from McMahon's courtroom, the *Star* had harsh words for justice courts in general. "This is to make a mockery of the law," the editorial said.

> *There can be no enforcement of liquor laws or any laws while taxpayers and voters suffer politicians to select and control the judges of these inferior courts. These inferior tribunals have long been a disgrace; they have been shown to have no place in the judicial system, and are maintained merely as a part of the political machinery necessary to the boss system.*

McMahon wasn't singled out for scorn, however. Justice John George once admitted he didn't believe in punishing anyone for possession of liquor or bartenders for serving it. "My records are open to the public," he said. "I am for light wines and beer." Edward Towne, a former city councilman, was said to handle more liquor cases than any other justice court. He became notable for lighting suspected liquor with a match. If it didn't burn, it wasn't booze, according to him. A charge against him of being drunk in court was dropped for lack of evidence.

The only Republican justice of the peace in town was Alex Saper, who had lost a foot in the war and worked in the country prosecutor's office before being appointed in 1922. He was considered tougher than others. "This is a terrible day for bootleggers, especially proprietors of soft drink parlors," he once announced as he opened his docket. "Bring 'em on!"

1809 Grand Boulevard

The popular jazz club in the little building just south of Eighteenth and Grand has the look and feel of a place that might have been a speakeasy. In the early 1920s, this was United Tire & Supply, one of seven tire shops and several more automotive-themed businesses in this block. Then, in fact, it did become a speakeasy. By early 1929, the little soft drink parlor was considered a nuisance joint. As such, it was padlocked by the U.S. government.

The Volstead Act allowed that a place where liquor was illegally sold or manufactured could be declared a nuisance and vacated—padlocked against all uses—for a year. The intent was to make property owners responsible for what went on inside their property—in other words, to keep them from renting to bootleggers. In 1921, the first padlock—and the first federal prosecution of a Volstead violation here—was put on a saloon, a nineteenth-century fixture at Fifteenth and the Blue River. Others soon followed, on the Orient Hotel downtown and on a couple of chicken dinner farms out in the county. By summer 1923, more than eighty joints

A judge padlocked a speakeasy at 1809 Grand Boulevard. *Author photo.*

had been thus closed. For a time, even private homes were padlocked. After families were forced to sleep in cars or neighbors' homes, locks came off homes, but injunctions remained.

These early cases were heard in the U.S. court of the Western District of Missouri, presided over since 1910 by Alba S. Van Valkenburgh. Van Valkenburgh, who issued that first padlock order, was soon joined in the district by Albert Reeves, added in 1923 because of the increased caseload caused by Prohibition. When Van Valkenburgh moved to the circuit court of appeals, Merrill Otis became the second U.S. district judge.

Reeves and Otis presided over some of the era's landmark booze cases. Reeves handed the district's first prison sentence to a speakeasy proprietor who pleaded guilty in 1923 as a persistent violator. Later, he imposed Kansas City's longest sentence—four years—on bootlegger Marion Stassi. Otis was responsible for the two years in prison served by Frank DeMayo, "king of the bootleggers." He also passed judgment on Ukiah Grape Products for its juice-into-wine sales.

Both were outspoken advocates of Prohibition. When a bootlegger declared most of his clients were "better class citizens" from the South Side,

Otis, a South-Sider himself, took issue. "I have visited at many homes in that district and have my first time to see any liquor in any of them," he said. "If any had been served I would have walked out and never returned." He called bootlegging "anarchy" and claimed in 1930 that Prohibition laws were supported by "a large majority of this country's population, because if they had not, some steps would have been taken now for their repeal."

Reeves rarely missed an opportunity to present his opinions on liquor in public. He told a tearoom luncheon that "Americans cannot drink and behave themselves—everybody knows that." Europe's climate was colder, he said, so Europeans drank slowly and calmly. An American threw down glass after glass. "And pretty soon he wants to take his gun and make a sieve of the roof."

1608 Main Street

Nearly surrounded by surface parking lots, the handsome two-story building stands alone on its side of Main, the nearest structure being a streetcar shelter. The steak-and-beer restaurant here is the sole occupant today, though in 1925, the building had three: a cheap hotel upstairs, a restaurant in the south storefront and a soft drink saloon next door. In July that year, federal agents raided the saloon and seized liquor. The bartender put up a fight. There followed a preliminary hearing before a U.S. commissioner. The commissioner—a judge-appointed officer of the federal court—asked one agent if it was true he had used foul language while making the arrest.

"Yes," he said. "He was resisting me."

The commissioner waved a copy of the arrest warrant.

"That is issued in the name of the President of the United States," he said. "That is sufficient reason for agents to act with becoming dignity in its enforcement." Then he dismissed the case.

The incident inspired a sarcastic *Star* editorial. "The manners of all enforcement officials should be strictly watched," it said, "and would it not be well to insist that they wear top hats, frock coats and gloves while making an arrest?"

Although those circumstances were unusual, federal agents in the early years of Prohibition did have enforcement problems. They were ineffective at times, corrupt at others. Coordination with police was rare. The local office suffered from a lack of manpower, with just a half dozen or so agents

who rotated through the regional system to keep bootleggers uncertain of new faces. (For events like big conventions, as many as one hundred agents were brought in to clamp down on liquor activity.) Many were ill-trained, sometimes conducting raids without necessary search warrants, which negated prosecution. Nationally, they were not well paid. Many were in the business for the wrong reasons. "It was as if the willingness to accept a meager salary," says author Daniel Okrent, "guaranteed you the lucky number in a fabulous sweepstakes."

> *The universal prize: a piece of the millions upon millions of dollars in bribes and blackmail that even a moderately adept agent could extract from the lawbreakers operating within his jurisdiction.*

That was brought home to Kansas City in the case of Arthur Curran, a Hupmobile salesman turned Prohibition agent. Curran had been a Republican candidate for county office in 1920 before opening an auto dealership and becoming chief of the government booze hunters here in 1922. Dividing the city into territories, Curran and his men routinely raided bootleggers, obtained evidence and, in exchange for cash, promised to not

Federal agents raided a speakeasy at 1608 Main Street. *Author photo.*

prosecute. They were caught in 1924, and Curran and three underlings were convicted of extortion and conspiracy to violate the Volstead Act. Each got two years in Leavenworth, the maximum penalty. The special prosecutor called it "one of the most sordid tales of graft and corruption" he had seen.

Things eventually improved. Agents were fingerprinted and photographed in an effort to prevent "shakedowns" and to keep ex-cons off the force. In 1927, a civil service exam was required, covering English, arithmetic, geography, the Volstead Act, search warrants and the proper way to file a raid report.

In May 1929, gangsters from around the country secretly met in Atlantic City to discuss how to better conduct business—dividing up territory and specific rackets—without fighting one another. Among attendees, Kansas City was represented by Johnny Lazia, Chicago by Al Capone. A few months later, federal agents began an investigation that culminated here in May 1931 with the breaking of a large liquor ring linked to Capone. Forty-seven locals were indicted, including Lazia. The *Star* reported "a Capone generalship, captained locally by John Lazia, Democratic boss said to have visited Capone in Florida last winter." It was hoped Capone might be caught up in the net, too. Instead, a week later he was indicted in Chicago for income tax evasion.

The agents in charge said their case was so complete that most of the forty-seven would forgo a jury trial and plead guilty. In the end, seven received prison terms. After an associate accepted responsibility for the charges and a hefty fine, Lazia went free.

406 East Eighteenth Street

The craft brewery on Eighteenth just east of Oak occupies a storefront that for many years was an auto-repair shop. The stairs next door lead to a second-floor space that, in the summer of 1932, was a speakeasy known as the Novelty Club. The club was notable for two things: its ornate bar came from the 1904 St. Louis World's Fair, and after being open just a few months, the place was raided in the largest-ever citywide sweep against speakeasies by federal agents.

Ninety-nine agents from several states gathered here in late September with a list of seventy-five speakeasies compiled by the district attorney.

Simultaneously, at 10:00 p.m. one Tuesday, they fanned out across town to the Reel Café, Kit-Kat Club, Cotton Club, Scotland Yard, Oak Tavern, Club Royale, Hawaiian Gardens and others.

Here, at the Novelty Club, according to the *Star*'s reporter, agents broke in the front door with an axe and ran upstairs, where "The orchestra just had begun a snappy tune and the floor was filled with dancing couples, some of the women in evening dress, others in street and sports wear, and men in dress and business suits."

Overall, the raid revealed a new brand of speakeasy had blossomed wide-open in this first year of the "home-rule" police department. These were no soft drink joints. Almost all had casino-style gambling equipment and white-aproned bartenders making fancy pre-Prohibition cocktails. Many used index-card systems to keep track of members. Several featured jazz orchestras and what were called "muscle dancers." The *Journal-Post* noted some had waitresses "who started the evening with a fair amount of clothing on but who discarded garments as the liquor flowed faster and faster."

Probably the biggest prizes for the raiding agents were the two places run by the Pusateri brothers, Gus and Jim. The Merchants Lunch, an often raided, sometimes padlocked North Side place that occupied a series of locations near city hall, had long been famous for steaks and top-notch booze. It was the popular choice of influential South Side business types and said to be partly owned by Johnny Lazia. "So popular and open was the police headquarters neighbor that an attendant took your car at the door," a reporter recalled years later. Oak Tavern, near Thirteenth and Oak, was more elaborate, reflecting the wide-open trend, with a dance floor and full-service casino. The Pusateris' index card roster held one thousand names. The day after the raids, a *Star* editorial asked rhetorically about the brothers' protection:

> *These men had operated an elaborate illegal business within a stone's throw of police headquarters, with slight interruptions, for years. Such was their confidence in their immunity that it had become a tradition with their customers that "the show must go on." Apparently people flocked there with the utmost confidence that they were in no danger.*

Both Pusateri clubs were padlocked for a year. Lazia's associate fronted the hefty $5,000 bond for Gus, who received a sentence of five months in county jail for maintaining a nuisance at Oak Tavern.

Highballs, Spooners & Crooked Dice

Once the Novelty Club, 406 East Eighteenth Street. *Author photo.*

The proprietor of the Novelty Club was Jack Randazzo, who had done time for stealing cars while running an auto-repair shop. In spring 1932, as new clubs began sprouting, a classified ad sent him into the speakeasy business: "406 E. 18th—2d floor; 4,000 square feet; excellent light; low rental."

Randazzo had somehow eluded capture in the September raids. Early in October, he was sitting in another club talking to a guy at the bar. "They knocked my place off down on Eighteenth Street," he said. "They didn't know it was mine, but it was. I had five thousand dollars in it." Unfortunately, the guy at the bar was a federal agent, who arrested Randazzo.

As the Pendergast machine accused the Republican district attorney of arranging the raids for political show ahead of the November election, government moving vans pulled up outside each club and hauled away tables, chairs, rugs, curtains, slot machines, glassware and liquor, as well as the entire 1904 World's Fair bar. Much of it was stored away to be auctioned. The bar from the Merchant's Lunch was shipped to the Leavenworth penitentiary wood shop to be repurposed into furniture. Gus Pusateri got permission to repaint his jail cell in red, white and silver during the six weeks he served of his five-month sentence.

Prohibition in Kansas City, Missouri

2860 Southwest Boulevard

The architectural mishmash of the low building on Southwest Boulevard, near the shadow of I-35, speaks to two original structures; one dates to 1914, the other to 1930. Tacos and margaritas have been the fare here for decades, but in the late 1920s, this was a much-raided speakeasy/gambling joint run by Edward J. Nettle, a former stockyards foreman. Early one morning in 1928, a small group of regulars were minding their own business at the bar when the door burst open and five men wearing dark overcoats, caps and handkerchiefs over their faces crashed in and raised sawed-off shotguns at the startled imbibers. One of the intruders actually shouted "stick 'em up!" before forcing Nettle to open a safe, the bartender to open the cash register and the eight customers to empty their pockets. Then they piled into a black Buick and laid rubber with about $900 and change.

Over the course of Prohibition, Kansas City developed a reputation as a crime-ridden place. In 1923, it was called "the confidence ring headquarters" of the United States. Two years later, statistics indicated the rate of homicides and major felonies here was double the national average. Major crime fell slightly in 1926, except for liquor raids and stolen cars. In 1928, the *Journal* noted that one of every three murder victims here had died "because of the influence of 'soft drink' or gambling joints." In 1929, a wire service reported "a number of nationally known figures of the underworld have made Kansas City their headquarters," including five of Al Capone's gunmen. By 1930, it had moved past Chicago in the rate of murders based on population. And the next year, it led the country in the number of felonies (based on population). In 1932, Kansas City was named with St. Louis as a center of a midwestern kidnapping trend. "Nowhere has the menace of the well-organized racket of kidnapping been more evident in the past year than in Missouri's two leading cities," one national correspondent wrote.

Then came 1933. The city had barely caught its breath after the gun battle at Union Station, in which four lawmen and their prisoner died, when another shootout occurred on Armour Boulevard. Ferris Anthon was a Syrian immigrant who had managed to become the most-arrested man in town, usually for selling alcohol, but had only done a short time in a workhouse. In 1932, apparently seeing an opportunity after Al Capone's imprisonment for tax evasion, he went to Chicago. A small-time bootlegger here, Anthon raised eyebrows when arrested there as part of a regional liquor ring that sold a half-million gallons in its short life. Free on bond, he returned to Kansas City just as beer became a legal product and a competitive racket.

Highballs, Spooners & Crooked Dice

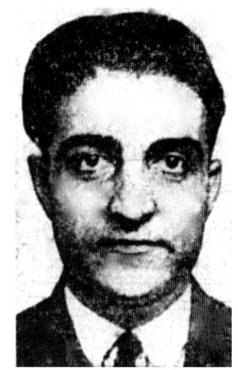

Right: Ferris Anthon. *Kansas City Times.*

Below: E.J. Nettle's former speakeasy, 2860 Southwest Boulevard. *Author photo.*

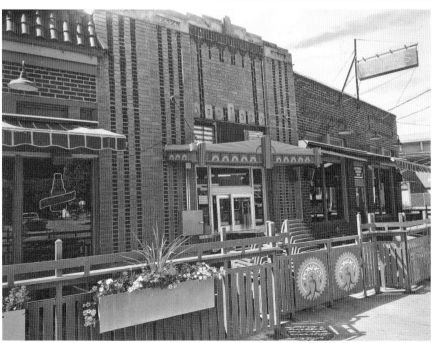

Early one morning, he was shot eight times outside his apartment at Armour and Forest. The county sheriff happened to be driving by and exchanged fire with the shooters, killing two and capturing a third—Charles Gargotta, a henchman for North Side political leader Johnny Lazia.

Anthon was just one of several bootleggers who died in gangland violence here. The problem was a national one, and Prohibition was to blame. "Organized crime was not new," noted author Lisa McGirr, "but the war on alcohol turned an entire industry over to criminal entrepreneurs who not surprisingly thrived as never before."

THIRD AND LOCUST STREETS

The concrete trail through the Richard L. Berkley Riverfront Park slithers under the south end of the old Armour-Swift-Burlington Bridge, completed in 1911. It's a good vantage point for watching freight trains grind slowly across the span, as they have for decades, and the muddy current of the Missouri River slide eastward, as it has for ages. Once, it was possible to see passenger trains and electric interurbans make this crossing and, when the upper deck existed, trucks and autos. On January 17, 1920, the day the Volstead Act took effect, a truck stopped midway across the bridge. A man got out, pulled more than one hundred cases of liquor off the back of the truck and heaved them into the river.

The man was Lieutenant Leo Mullin, clerk of the police department's property room. The liquor had been seized during wartime prohibition, and twice a year, this was how he disposed of nefarious contents of the room. The fruits of vice raids tossed over the railing here included guns, black jacks and weapons of all types; slot machines (with thousands of dollars in nickels, dimes and quarters) and other gambling devices; and bottles of beer, gin and whiskey. This was not the only way confiscated booze reached the river, however. Often it went into the sewers outside a raided house or speakeasy. In 1925, federal agents emptied thousands of gallons of distilled hair tonic into the backyard of a house on Olive Street, flushing it with a garden hose to the storm drain. The next year, a huge cache of bonded liquor, shipped in boxcars from Biloxi behind sacks of oyster shells, went from the government warehouse into the sewer.

Other contraband was disposed of at auction, including a Ford coupe, minus the 50 gallons of alcohol it contained when seized; a still and

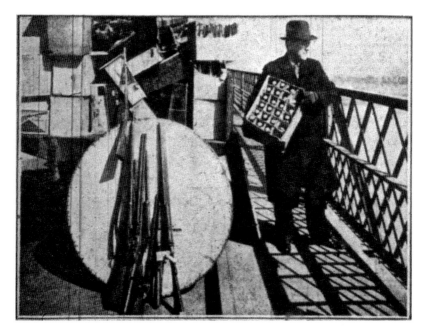

Lieutenant Leo Mullin, ready to toss beer from the Armour-Swift-Burlington Bridge. *From the* Kansas City Journal-Post.

Armour-Swift-Burlington Bridge, near Third and Locust Streets. *Author photo.*

accessories taken from a 1,500-gallon capacity operation in the West Bottoms; and chairs, tables, upholstered booths, beer mugs, highball glasses, roulette wheels, a player piano and ornate bars from various speakeasies. Sometimes auctions were an alternative to Volstead Act prosecution. Authorities could invoke older revenue laws, an action requiring seized items to be sold rather than destroyed. At such auctions, speakeasy owners could actually buy back their own stuff.

Then there was the axe squad, the speakeasy-busting police unit. Although this group existed before Prohibition, it became a particular favorite in the summer of 1921, when the police chief declared his hardline cleanup would include demolishing any place found selling liquor. On a few occasions, faced with concrete vats of corn mash, police resorted to dynamite.

Lieutenant Leo Mullin opted for the ASB Bridge. On April 7, 1933—the first day real beer became legal again—Mullin returned to the bridge with a dozen or so shotguns, a policy wheel and thousands of bottles of beer and whiskey. Just as on Prohibition's first day, a photographer from the *Journal-Post* came along. It was a sunny, chilly spring day. Mullin, in overcoat, gloves and fedora, posed holding a case of beer. The river then was said to be two fathoms deep below the bridge, about twelve feet. The drop from the auto deck would have been thirty feet or more. The next day, the photo was headlined "Brew Makes Splash."

7
SOMETHING MORE THAN BEER

You probably would have followed with great interest—and relief—news of the House of Representatives voting on February 20, 1933, to repeal the Eighteenth Amendment.

Four days earlier, the Senate had also done so. Now it was up to the individual states to ratify the Twenty-First Amendment and end Prohibition.

On March 4, Franklin Delano Roosevelt took his first oath of office as president. On March 12, after signing his Emergency Bank Act into law and restoring Depression-ravaged America's confidence in capitalism, he declared, "I think this would be a good time for beer." On March 22, he signed the Beer and Wine Revenue Act, which legalized beer with an alcohol content of 3.2 percent and restored a source of tax revenue for the government.

On April 7, legal beer flowed again. That day, two cases of Budweiser were delivered to Kansas City on a Transcontinental & Western airliner from the Anheuser-Busch brewery in St. Louis to Thomas J. Pendergast and his nephew James M. Pendergast.

On August 19, Missourians voted to ratify the repeal amendment by a three-to-one margin. It was ten to one in Kansas City. The "machine unlimbered its vote-getting organization to turn the test into a rout," said the *Star*. The Anheuser-Busch company of St. Louis took out a celebratory ad. "Something wonderful has happened to all of us," it began.

We are coming out of the dark. Even the air holds new freshness, new hope. We looked so long at the clouds, we forgot the blue sky beyond. Now we are seeing it again. And it looks good. America feels better!...Something more than Beer is back.

109 WEST EIGHTEENTH STREET

The three-story, multipurpose arts building midblock on Eighteenth between Wyandotte and Baltimore bears the name of its original tenant, the Bauer Machine Works company, makers of gasoline engines. In the early 1930s, three street-level storefronts included a large space at the east corner, now a gallery. Five days after President Roosevelt declared, "The only thing we have to fear is fear itself" at his first inauguration, two weeks before he signed legislation that made beer legal again, federal agents raided the Jewel Club, a high-end speakeasy in this space.

The Jewel Club was roomy, with fifty or so tables, lounge chairs, a circular bar, a dance floor and a casino room for roulette and blackjack. A blue canopy covered the ceiling; lights were low. One of the owners was Sam Scola, who had been among those arrested but not imprisoned in the bust of the 1931 Capone alcohol ring, and who would die in the August ambush of Ferris Anthon.

A day before the raid, officials in Washington announced appropriations for Prohibition enforcement were being cut. Funding was no longer available for wiretapping or to pay informers or to make liquor purchases in speakeasies. The national Prohibition director said this would "make it virtually impossible for the bureau to be effective against speakeasies in most jurisdictions." Agents were told to concentrate on the sources of illegal liquor; speakeasies would be left to states to deal with.

Agents in Kansas City were not giving up. They had a new trick up their sleeves—motion-picture surveillance. And what better place for a test run than the Jewel Club in the neighborhood where Hollywood studios operated distribution warehouses. For two weeks, agents had been watching this club and another, the Palais Imperiale near Seventeenth and Oak. Patrons entered sober and left apparently intoxicated. The agents discreetly set up cameras, filming the comings and goings. Believing they had good evidence, they raided both clubs on a Thursday night.

"We had search warrants, but didn't need to show them," said the chief agent. "We were admitted at the Jewel Club by a doorman who merely

Highballs, Spooners & Crooked Dice

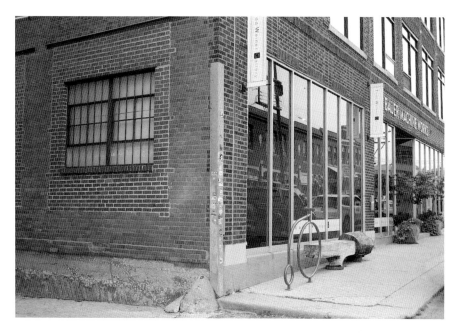

The former Jewel Club, 109 West Eighteenth Street. *Author photo.*

asked us if we had membership cards. We nodded, and didn't even have to show the cards." They arrested six men, but it soon became apparent that convictions would be unlikely without agents having witnessed actual sales of liquor. No doubt this disappointed the filmmakers.

"If these cases go to trial," said one, "courtroom spectators may be surprised at who some of the persons seen entering and leaving the club are."

1717 West Ninth Street

The West Bottoms stretch of Ninth between Genessee and State Line isn't the lively block it once was. Chain links and warehouses give it an industrial feel today, though remaining buildings include a combination liquor store/deli and an antiques dealer. An ancient, two-story brick structure with tall second-floor windows awaits renovation. There are no clues as to why it should be newsworthy, as it was on the morning of April 7, 1933, when a *Times* headline announced:

THE WET BLOCK IS READY
SIX PLACES WILL SELL BEER TODAY
IN 1700 BLOCK ON WEST 9TH

It was the first day of legal beer in more than thirteen years, and the *Times* was revisiting a neighborhood it had labeled in 1907 "the wettest block on earth." Back then, the paper reported there were twenty-nine buildings in this block:

> *A dry goods store uses one, a grocery store another; that leaves twenty-seven. Two are used by pool halls, leaving twenty-five. Twenty-four—two dozen—are occupied by saloons, leaving one. That one is vacant—it's being fitted for a saloon. After that, unless the dry goods store and grocery quit, new saloons will have to seek the second story.*

In April 1933, the number had shrunk to six, including the lunchroom in this building, home in the 1890s to the Pendergast Brothers Saloon. Young Tom, down from his native St. Joseph, Missouri, went to work in the family business, then lived above the saloon owned by his elder brothers Jim and John. The saloon once claimed to have the longest bar in the country, according to the 1933 story. That claim was disputed the next month in the *Journal-Post*, which cited the mahogany bar down the street at Flanagans as the one-time longest at one hundred feet (but now just twenty-five). Most of the saloons were then owned by breweries, including Heim, Muehlebach, Schlitz and Rochester.

Before Prohibition, the "wet block" was under constant fire from dry advocates and officials from across the line in dry Kansas, where many of the block's customers lived and worked. "If the wet block were to be abolished the police court could be closed," a Kansas judge said in 1917. "It would not only be a fine thing for Armour & Co., but for the citizenship of both Kansas Cities if the 'wettest block' were wiped out of existence," an Armour spokesman said that same year, when the meatpacker employed thousands in a plant just a bottle's toss across the state line from two dozen saloons.

By 1921, those two dozen had become nine soft drink parlors. Throughout Prohibition, the number fluctuated, but liquor remained a constant. Here, the former Pendergast saloon endured a series of setbacks—a proprietor got thirty days in 1927 for selling booze; padlocks arrived in 1928 and 1929. Finally, legal beer reappeared. That April 1933 evening, the *Star*

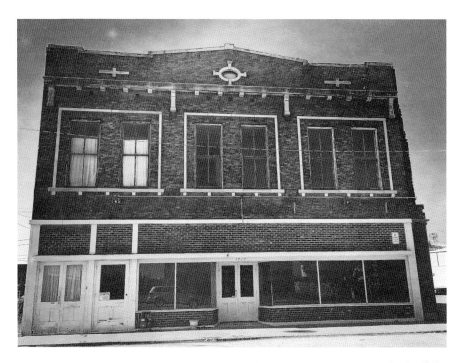

Above: A former wet block saloon, 1717 West Ninth Street. *Author photo.*

Right: Goetz ad from the day beer reappeared, April 7, 1933. *From the* Kansas City Journal-Post.

reported someone had counted 398 Kansas license plates parked in and around the "old wet block":

> Business flourished there in the five places selling the beer. Carpenters, plumbers, and other tradesmen were active in at least five other buildings that have borne "for rent" signs. In one place there was a crowd two deep when the spigot was turned for the first glass at nine o'clock. It still was as deep at noon. Three bartenders filled the glasses as fast as the spigots were turned.

By May, joints that had once featured sawdust floors and brass cuspidors were being refitted in new ways. The old Flanagan saloon was getting linen tablecloths, silk lamps and pile carpeting. A man who had owned one of the old-time places was investing in three new ones, ready to make the block wet again as soon as the Eighteenth Amendment was repealed.

7321 East Fifteenth Street

Just west of the Blue River, under the divided four-lane viaduct, is a remnant of what used to be called Fifteenth Street, the original name of Truman Road. The lonely brick structure at the corner of Eastern Avenue has seen better days, but probably not for a while—maybe not since real beer again became a legal intoxicant in 1933. That May, a small ad appeared in the *Journal-Post* for a business in this building. "Visit Fritz Muder's Beer Garden," it read.

Since the last years of the nineteenth century, this had been Muder's home and saloon, one of many in the industrial neighborhood known as Centropolis. When Prohibition began, Muder was a sixty-one-year-old immigrant with a German accent and a tough barroom. He and another Centropolis saloonkeeper, Harvey Leopold, were often called before authorities to defend the renewal of their liquor licenses. Neighbors protested that Muder's and Leopold's places were "hell holes" and "harborers of thieves." Factories like Butler Manufacturing and the Ford Motor Company complained that their workers drank away their paychecks here. The war didn't help; German immigrants were suspected of being enemy sympathizers.

With Prohibition, Leopold's joint became notorious for illegal liquor sales. He was often arrested, his place padlocked. There's no evidence that

Highballs, Spooners & Crooked Dice

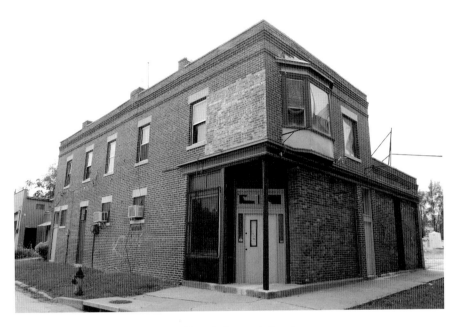

Muder's former saloon, 7321 East Fifteenth Street. *Author photo.*

Muder served anything but near-beer—he called his place a "delicatessen" then—but it's difficult to believe any rough-edged, working-class bars were alcohol-free.

In 1925, Muder's wife was held up as she withdrew $4,500 for the delicatessen from a downtown bank. The saloon's African American dishwasher, a war veteran who accompanied Mrs. Muder to the bank, shot the robber dead. In 1931, an armed robber confronted Muder, then in his seventies, at the saloon. "I can't afford to be held up," Muder said. "I'm not going to be held up. But if you'll wait until I get my gun, I'll shoot it out with you." The robber fled.

So the breezy 1933 advertisement for Muder's place must have raised a few eyebrows among some of the old neighbors and factory workers: "Kansas city's oldest family beer garden. A refined and pleasing place for ladies and gentlemen. Leading brands of beer on tap or in bottles. Good food to go with it."

Prohibition in Kansas City, Missouri

1822 Vine Street

The vaguely Spanish-looking, buff-brick structure on the west side of Vine, south of Eighteenth, has been just a façade for years, a false front propped up like a movie set. An arson fire destroyed the building in 1984, and by some miracle of preservation, this section remains, waiting to be made whole again in the Jazz District's redevelopment. It was, in fact, part of the scenery in Robert Altman's jazzy 1996 film *Kansas City*, in which it played its original real-life self, the Eblon Theater. The fictional story is set in 1934, a year after the real Eblon's demise and makeover, announced in a *Call* headline in early February 1933:

> *THE CHERRY BLOSSOM*
> *A NEW NIGHTCLUB*
> *TO OPEN HERE NEXT MONTH*

It had been ten years since the Eblon opened as a silent movie house. Now the seats were coming up, a dance floor was going down and the new club would be "decorated in the Japanese style." The decorator's name was Ananias Buford, a painter and carpenter previously responsible for Hawaiian Gardens, a North Side club with a similar theme that fell victim to booze raiders a year earlier. "A fast floor show and a good dance orchestra will be permanent features," said the *Call*.

Gambling joints and speakeasies had long existed in this neighborhood, but nothing as complete and elegant as the Cherry Blossom. Perhaps closest were the Blue Room, a bar in the Hotel Street at Eighteenth and Paseo, scene of dances and private parties, and Dreamland, an upstairs dance hall a few blocks south on Vine. A 1931 police raid at Dreamland focused on a "black-and-tan" dance sponsored by the League of Struggle for Negro Rights, an early civil-rights group. A *Call* editor was there to hear one cop declare that "God made the two races separate and he meant for them to stay that way."

Black-and-tan joints predated Prohibition but became more popular as illegal drinking and gambling mixed with jazz music and liberated women. "White folks like to visit Negro cabarets even if the law doesn't permit it," the African American *Sun* observed in 1920. "They say they get more warmth and jazz than they do at their own."

No such laws existed, but somehow stiff fines were common. White society frowned on racial mixing. The Society for Suppression of

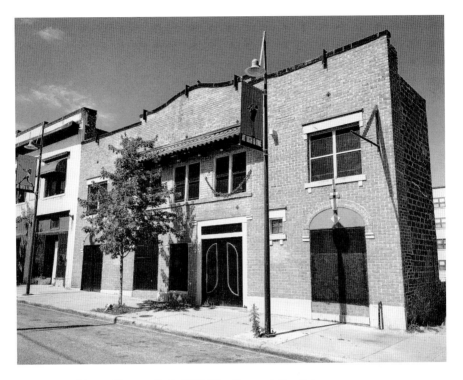

The former Cherry Blossom Club, 1822 Vine Street. *Author photo.*

Commercialized Vice warned of places "where whites and blacks mingle in the most dangerous manner." In late 1920, after a raid on a black-and-tan cabaret near Twelfth and Vine, the *Post* suggested South Side "slummers" were to blame. "The vice squad is making a drive to clean out places where Negroes and whites mix," the paper said. "Idle white women, looking for thrills in cabareting, are patronizing such places widely." In 1926, after a place at Sixth and Washington had been raided fourteen times and finally padlocked, the *Star* sniffed: "It had been considered good etiquette there for the two races to mix in their dancing."

Dreamland Hall received its own makeover during that spring of 1933, becoming the Club Ritz—"owned by Negroes and employs plenty of Negro labor." The Ritz opened the April night when legal beer flowed again. One night later, the Cherry Blossom's delayed opening attracted more than 1,100 patrons. They marveled at dragon motifs, Asian landscapes, waitresses in kimonos, two Chinese cooks and a plaster Japanese god towering behind George E. Lee and his Brunswick Orchestra. Designer Buford, also the club manager, called it "the finest nightclub ever opened for Negroes in this city."

Two weeks later, the Hotel Street's Blue Room reopened as a new "high class supper club" called the Crystal Palace. Management promised, "All patrons will be accorded the same courteous treatment."

1414 East Fifteenth Street

St. Stephen Baptist Church, at the northeast corner of Truman and Paseo, is actually three different buildings combined. The deco section on the east was part of a 1940s renovation. An older brick section on the west, faced with faux stone, was once a garage. The middle section with its decorative arch over second-floor windows was originally the entrance to a large dance hall, now the church sanctuary. The dance hall was known as Paseo Recreation Hall, and in the 1920s, it was a center of African American night life.

During Prohibition, popular jazz orchestras could bring more than two thousand dancers to the floor of "The Finest Hall in the West," according to authors Chuck Haddix and Frank Driggs:

> *Music and gaiety poured out of the large windows surrounding the hall to entice passersby at the busy intersection. Entering through the double doors on Fifteenth street, patrons purchased tickets at the box office window on the left. Staircases flanking the entrance to the ballroom on either side led to the balcony, where music lovers watched nattily dressed dancers two-stepping across the gleaming wood floor. A huge mirrored ball, suspended from the ceiling, presided over the festivities.*

In spring 1933, with the legalization of beer and the anticipation of complete repeal of the Eighteenth Amendment, new nightclubs began opening around town. In May, the *Journal-Post* began a "Nightclub Notes" column to promote those brave enough to dip their toes into advertising. By early June, the column was claiming (for maximum ad revenue) that "the big nightclubs have been flourishing and instead of slacking off with the advent of warm weather, patronage of the gay places is increasing."

New clubs (and ones new to advertising) included the Silver Slipper on Warwick, Cotton Club at 101st and Holmes, Band Box on Troost, Broadway Gardens on Broadway and Il Pagliaccio on the North Side. The new African American clubs did not advertise in the mainstream press.

The former Harlem Nightclub, 1414 East Fifteenth Street. *Author photo.*

In late June, the *Call* reported Paseo Hall was being remade as the Harlem Nightclub. It would be redecorated in shades of blue and have new lighting, "the best traveling bands" and "plenty of seats for spectators around the hall." The grand opening would be July 1. In late July, a blurb ran in the *Journal-Post*'s "Nightclub Notes," promoting the club's booking of the George E. Lee orchestra for "an indefinite engagement." The next week, an ad appeared. "A New Thrill in Nite Life," it read. "Dance on K.C.'s Largest Nightclub Dance Floor." Then came the kicker: "White Patronage Exclusively."

There had been a change in policy at the Harlem Nightclub, one that mimicked the famous Cotton Club in New York's Harlem—black entertainment for white audiences. "The exclusively white patronage, of course, includes some of our first citizens who believe the originators of jazz are naturals as nightclub entertainers," the *Journal-Post* columnist wrote.

It was a blow to the local community. As Haddix and Driggs write, "Finding the doors to the Harlem Club slammed in their faces, African American patrons switched to the Cherry Blossom."

1706 BALTIMORE AVENUE

The building at the southwest corner of Seventeenth and Baltimore was once part of the little "film colony" in this neighborhood where various Hollywood studios warehoused their latest releases for regional distribution. In this case, the studio was United Artists. By the summer of 1933, however, night life had replaced film reels, and this became the Paramount Club, billed as "Kansas City's Smartest Nightclub." Attractions included a ten-piece orchestra and floor show, and the *Journal-Post*'s reviewer called it "an attractive place which has a wide reputation for its Italian and American dinners."

That August, Missouri became the twenty-second state to ratify repeal of the Eighteenth Amendment. The springtime trickle of new clubs became a steady flow into fall and winter. Beer was still the advertised libation, but smuggled flasks were surely common. Early arrivals included the Ritz Supper Club, Vanity Fair, Palms and Club Paradise. One new club, the Grotto, was fashioned from an abandoned limestone quarry near Bannister and Holmes out in the county. The old caverns were paved and wired for colored lights and enhanced with a modern kitchen, tables and a dance floor. "Most Unusual Dine & Dance Place in the World," it boasted. "Cut from Living Rock."

Milton Morris left the bookmaking Saratoga Club and partnered with Nugent LaPoma in a North Side joint next door to LaPoma's house at Fourth and Cherry. Patrons of their Hey-Hay Club ("Kansas City's Different Nite Club") sat on hay bales around wooden barrel tables and enjoyed an oddball floor show and music by "Dew Kellington's" band. Frank "Big Sugar" Cipolla, former king-size bartender at Pusateri's infamous North Side speakeasy, opened the Alamo Supper Club at Thirty-Fourth and Main.

The Coconut Grove, with a Pacific island theme ("Among the Sheltering Palms") at Twenty-Seventh and Troost, opened at the end of September with a huge dance floor and all-black entertainers, making it a competitor of the Harlem Club. That same night, the former Pompeii Café, downstairs from the Merchants Bank at Fifth and Walnut, reopened as the Pirate's Den ("Kansas City's Most Novel Nite Club") with a greeter named Captain Kidd.

The Gayety Theater's switch from burlesque to motion pictures probably helped inspire a new type of nightclub. One was the Chesterfield Club ("Come Down and See the Girl Dance") on Ninth between Oak and McGee, run by Gus Gargotta, brother of infamous henchman Charlie. The *Journal-Post* noted the entertainment at the Chesterfield was the same type as the

The former Paramount Club, 1706 Baltimore Avenue. *Author photo.*

"Streets of Paris" show at that year's World's Fair in Chicago. (Translation: naked ladies.)

Early in December, three days before Utah's repeal vote put an end to Prohibition, Dante's Inferno opened at Independence Avenue and Troost, where the Club Royale had operated until it was padlocked in 1932. The proprietors remained the same: the Lusco brothers, one of the groups that formed the sugar syndicate. Joe Lusco, the eldest brother, was a North Side political rival of Johnny Lazia. In 1931, the fugitive Pretty Boy Floyd had holed up in rooms above his Lusco-Noto flower shop on Independence near Dante's. Floyd shot his way out during a raid by federal agents, killing one of them.

James and Salvatore "Tudie" Lusco bartended at Dante's, which featured hellish decor, waitresses dressed as devils, a band called the Dragons, a stripper and female impersonators. "Dante's Inferno," said the *Journal-Post*, "doubtless will get a big play from night life thrill seekers." A week after opening, Dante's got a big play from police raiders, who arrested Tudie Lusco and a young woman. They were charged with presenting an "immoral dance."

8
WET AND WICKED

It would have been difficult, wrote Daniel Okrent, to determine the country's "wettest" city during Prohibition. His list of possibilities includes New York, Chicago, Baltimore, San Francisco and New Orleans, with Detroit as the leading contender. Had he been around in 1934, Okrent might have gotten an argument from a Frenchman named Georges Valot, who toured America that year doing research on alcohol consumption. When he sailed for France in September, Valot spoke with reporters. His three booziest U.S. cities were Reno, New Orleans and Kansas City. Beyond that, one stood out as "wickedest town."

"I have seen the streets of Paris at their worst, or best, but they are nothing like Kansas City," he said. "If you want to have a good time, go to Kansas City."

Perhaps this was a carryover from Prohibition. Gambling and prostitution and corrupt police had long coexisted with alcohol in most cities. Most cities regained control after repeal of the Eighteenth Amendment. Much of Kansas City's "wide-openness"—its nearly unfettered boozing, gambling, nudity and prostitution—blossomed after repeal.

New Year's Eve 1934 had been celebrated without benefit of a new state liquor law in Missouri, but that didn't keep the booze from flowing. In the last days of 1933, after Utah made repeal official, Kansas City drugstores and other retailers began selling bottled liquor. Nightclubs had it, too, but many patrons carried their own to the holiday festivities.

The Missouri legislature finally passed a liquor law on January 12, 1934. One of the hang-ups had been that St. Louis was awarded local control

of its liquor flow, but not Kansas City. That changed when T.J. Pendergast got involved, backed by hotel proprietors. The first state liquor control commissioner was a Kansas City man. "I did not apply for the job," he said. "Mr. Pendergast made the application for me. I have known him forty-four years."

Missouri legalized liquor by the drink in larger cities, leaving smaller towns to decide by popular vote. Annual federal and state licenses were required; Kansas City's ordinance added a $450 license fee. Drugstores, groceries and other retailers could sell only packaged liquor. Closing time was midnight.

Such were the limits to be crossed on the way to a "wide-open town." Nightclubs, now free to advertise liquor, sprouted across town like neon dandelions. By June, eight hundred federal licenses had been issued here, but just four hundred–plus city and three hundred–odd state licenses. Closing times were only a suggestion.

In 1944, a *Star* editorial would look back on the previous ten years:

> *The machine was a huge, sprawling business and its object was money.... They made a gaudy showcase labeled "wide-open town," the showcase was rumored to attract big conventions, traveling men and good citizens who liked to get away occasionally from the restraints of the smaller towns to the big city where they weren't known...not only the bosses but thousands of others went about their business as if Kansas City had seceded from Missouri and the United States.*

Indeed, it had become the Paris of the Plains.

A Few Postscripts

Tony Barelli moved Tony's Place to Fifth and Cherry before dying of a ruptured appendix in 1937. His wife took over, and Jennie's Italian Restaurant remained popular until it closed in 1998.

Swede Benson got involved in a love triangle and, in 1934, shot and killed a man on a northern Missouri farm. He fled and was captured four years later in Los Angeles and eventually sent to prison for second-degree murder.

Nardo Bivona reopened the Amo Café in 1934 as the Oriental Club. Liquor violations closed the club in 1939. Bivona died at sixty-five in 1952.

Guy Brock, after doing time for bootlegging, moved to California and opened Brock's Barbecue and Cocktail Lounge in Sausalito. His 1952 obit described him as "a connoisseur of good food."

Piney Brown ran the famous Sunset Club at Twelfth and Highland for Felix Payne. He became nationally known after his two former house musicians, Pete Johnson and Big Joe Turner, recorded "Piney Brown Blues."

Annie Chambers died in 1935 and willed her former house of prostitution to the City Union Mission, where she had found religion in her waning years.

In the summer of 1934, the Cherry Blossom adopted a "Both White and Colored Patronage" policy. "Oh, oh…it works in New York's Harlem where the races intermingle in hi-de-ho," the *Journal-Post* said. "But will it work here? Not long, probably." It closed in 1935 but became first Scott's Theatre-Restaurant and, later, Chez Paree in the 1940s.

Matthew Clarkin opened Tootie's Mayfair, a jazz roadhouse, at Seventy-Ninth and Wornall, then Eighty-Fifth and Prospect, then east Highway 40. Before closing in the 1950s, Tootie's presented, among others, Ella Fitzgerald, Miles Davis, Billie Holiday and Charlie Parker. Clarkin died in 1982.

Friends of Jack Copelman—including Gold Tooth Maxey and Gus Pusateri—helped finance parties in his name for inmates of the Kansas City Tuberculosis Hospital at Leeds. Copelman died in 1949; the parties continued into the 1960s.

After two years in prison for bootlegging, Frank DeMayo ran an oil and lumber businesses. His application for U.S. citizenship was rejected in 1938, and he filed for bankruptcy in 1940. He died in his Benton Boulevard home in 1949.

Judge Edward Fleming died of a heart attack at fifty-seven in 1942 while watching a movie at the Orpheum Theater.

Charlie Gargotta, acquitted in the Anthon murder, was shot dead with political leader Charles Binaggio in 1950. The murders were never solved. Brother Gus avoided prosecution for murder in 1938 when a witness declined to testify. His Chesterfield Club ran afoul of liquor laws in 1939 and closed. He moved to Oklahoma in 1950 and became a produce wholesaler. His

A 1950s ad for Matt Clarkin's roadhouse. *From the* Kansas City Star.

1967 obit said he was "noted for his feeding of persons on Thanksgiving, Christmas, and New Year's."

The Grotto, the nightclub in a cave, closed after women complained its dampness ruined dresses and hairdos. In 1950, the county sheriff said the abandoned quarry could hold about 100,000 people in the event of an atomic bomb attack.

The Harlem nightclub was bombed three times in the winter of 1934–35 and later reopened at Twenty-Seventh and Troost in the former Coconut Grove space.

Agnes Keller ran a notorious bawdy house in San Diego after leaving Kansas City. She wound up doing two prison terms in San Quentin for grand larceny and grand theft.

Johnny Kling bought controlling interest in the Kansas City Blues in 1933 and sold them to the New York Yankees' Jacob Ruppert in 1937. Testimony in 1939 indicated his Baltimore Recreation had paid gambling tribute money to the Pendergast machine.

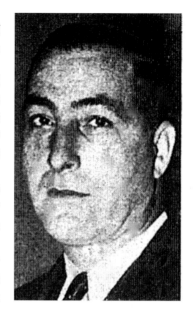

Joe Lusco. *From the* Kansas City Journal-Post.

Joe Lusco survived an assassination attempt in 1935 and died in 1945. Tudie Lusco opened the Stork Club in the old Paramount Club space at 1706 Baltimore; liquor violations closed it in 1939. Later, he owned the original Majestic Steak House at Thirty-First and Holmes, a favorite of baseball luminaries like Joe DiMaggio, Ted Williams and Mickey Mantle.

In 1939, Gold Tooth Maxey told a reporter he'd retired from gambling in 1934. "There's just a bunch of chiselers around these days," he said. "They shoot for nickels now. Why, I wouldn't snap my fingers for less than two grand in the good old days." He died in 1952 at sixty-eight.

Milton Morris opened a succession of jazz clubs after the Hey-Hay Club—the Dump, the Novelty Club (recycling that name), and several versions of Milton's—with the last closing after his 1983 death. His obit repeated his dubious claim to have "brought black music to white audiences for the first time" in Kansas City. It also remembered him as "an embroidering storyteller."

Ed Nettle's former business partner and the croupier of his crap game were found dead in the Sportsman's Club in 1934, both shot in the head.

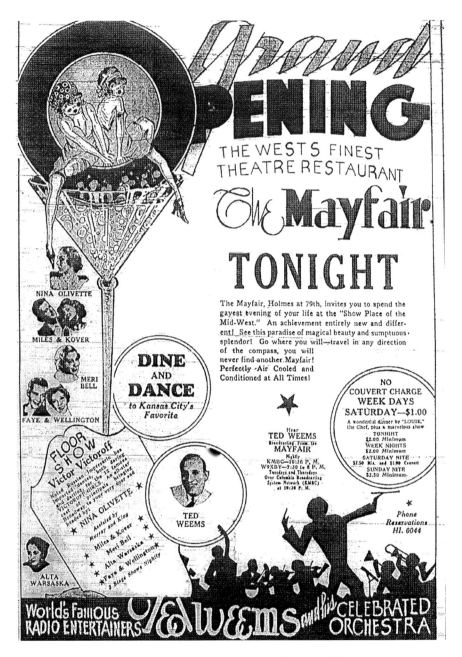

Gus Pusateri's Mayfair opened in 1935. *From the* Kansas City Journal-Post.

"They were going to kill me," Nettle reportedly told the cops before he was charged with second-degree murder. "But a man has to defend himself, doesn't he?" The case was dismissed when witnesses asserted it was self-defense. Nettle died of a heart attack in 1951 at age fifty-three.

The Pusateris, Jim and Gus, became well-known restaurateurs. In 1935, Gus opened the Mayfair, an elaborate supper club and casino at Seventy-Ninth and Holmes. The Andrews Sisters were performing there—they later called it their first big break—when the club burned down in 1936. Gus joined Jim at Pusateri's downtown, a longtime fixture on Baltimore.

In 1938, Nat Spencer promoted a state law to exclude women as barmaids, service girls or customers in saloons or taverns.

Fannie Taylor died in 1958 at ninety-four. Late in life, she was still sponsoring Woman's Christian Temperance Union programs with subjects like "Building for Total Abstinence Through Legislation, Health, and Good Morals."

Selected Bibliography

In addition to many hundreds of clippings from daily and weekly newspapers, primarily those of Kansas City but also nationwide, my sources included magazine articles and books. I list the following as being of substantial help or representative of the range of materials consulted.

Abbot, Karen. *American Rose: A Nation Laid Bare—The Life and Times of Gypsy Rose Lee*. New York: Random House, 2010.
Allen, Frederick Lewis. *Only Yesterday: An Informal History of the Nineteen-Twenties*. New York: Harper & Rowe, 1931.
Brown, Theodore A., and Lyle W. Dorsett. *KC: A History of Kansas City, Missouri*. Boulder, CO: Pruett, 1978.
Burns, Eric. *1920: The Year That Made the Decade Roar*. New York: Pegasus, 2015.
Crouch, Stanley. *Kansas City Lightning: The Rise and Times of Charlie Parker*. New York: Harper Perennial, 2013.
Dickson, Paul. *Contraband Cocktails: How America Drank When It Wasn't Supposed To*. Brooklyn, NY: Melville House, 2015.
Driggs, Frank, and Chuck Haddix. *Kansas City Jazz: From Ragtime to Bebop—A History*. New York: Oxford University Press, 2005.
Haskell, Harry. *Boss-Busters & Sin Hounds: Kansas City and its Star*. Columbia: University of Missouri Press, 2007.
Larsen, Lawrence H., and Nancy J. Hulston. *Pendergast!* Columbia: University of Missouri Press, 1997.

Selected Bibliography

McCullough, David. *Truman*. New York: Simon & Schuster, 1992.

McGirr, Lisa. *The War On Alcohol: Prohibition and the Rise of the American State*. New York: Norton, 2016.

Miller, Richard Lawrence. *Truman: The Rise to Power*. New York: McGraw-Hill, 1986.

Morgan, H. Wayne. *Drugs in America: A Social History 1800–1980*. Syracuse, NY: Syracuse University Press, 1981.

Okrent, Daniel. *Last Call: The Rise and Fall of Prohibition*. New York: Scribner, 2010.

Ouseley, William. *Open City: True Story of the KC Crime Family 1900–1950*. Kansas City, MO: Ouseley, 2008.

Pearson, Nathan W., Jr. *Goin' to Kansas City*. Urbana: University of Illinois Press, 1987.

Reddig, William M. *Tom's Town: Kansas City and the Pendergast Legend*. Philadelphia: J.B. Lippincott Company, 1947.

Rowley, Matthew. *Lost Recipes of Prohibition: Notes from a Bootlegger's Manual*. New York: Countryman Press, 2015.

Umland, Rudolph. "Crazy About History." *City Window*, August 9, 1974.

Walllis, Michael. *Pretty Boy: The Life and Times of Charles Arthur Floyd*. New York: St. Martin's Press, 1992.

Index

A

alcohol, denatured 28, 42, 45
American Legion convention of 1921 95
Anti-Saloon League 63
Armour-Swift-Burlington Bridge 73, 128
automobiles as tools of vice 32, 38, 47, 60, 77, 78, 79, 108, 114

B

Baltimore Avenue and Twelfth Street 21, 68, 88, 96, 98, 116
beer 32, 34, 131, 134, 136, 142
bondsmen 118
bookmaking and racing 70, 71, 72, 74, 101, 142
bootleggers 20, 27, 28, 30, 32, 40, 41, 47, 50, 54, 59, 60, 65, 72, 73, 74, 78, 89, 102, 113, 114, 119, 122, 126
bootleg supply stores 30, 34
breweries 23, 32, 134
brewery district 34, 92
Bunker building 48
burlesque 66, 98, 114, 142

C

cabarets 43, 48, 50, 79, 84, 88, 89, 110, 138
Capone, Al 34, 40, 123, 126, 132
chamber of commerce 21, 102
chicken dinner farms 51, 88, 108, 113, 116, 119
Clarkin, Matthew P. 92, 111, 146
cocktails and accessories 43, 57, 58, 79, 92, 98, 124
Country Club Plaza 53

Index

D

dancing 48, 51, 78, 80, 81, 83, 139
DeMayo, Frank ("Chee-Chee") 28, 40, 44, 120, 146
Disney, Walt 44
drugstores 29, 42, 43, 44, 46, 54, 56, 67, 74, 92, 96, 144

E

East Bottoms 21, 25, 38, 112
Eighteenth and Vine 84, 138

F

federal agents 28, 32, 35, 37, 40, 41, 42, 50, 55, 56, 63, 68, 74, 92, 96, 103, 104, 113, 121, 122, 123, 128, 132, 143
Fitzgerald, F. Scott 21
flaming youth 81, 82, 103
Floyd, Charles Arthur "Pretty Boy" 65, 143

G

gambling and gamblers 31, 50, 51, 52, 54, 56, 57, 58, 60, 68, 70, 89, 95, 96, 97, 100, 105, 111, 113, 116, 124, 126, 128, 138, 144, 147
Grand Avenue Temple 60, 70
Gumbel Building 23, 40, 42, 90

H

home-brew 20, 23, 34, 56, 80
home parties 56
home rule 104
hotels 18, 21, 23, 43, 48, 54, 55, 56, 63, 65, 68, 70, 74, 87, 88, 90, 91, 92, 93, 95, 96, 98, 100, 101, 103, 119, 138, 145

J

Jackson Democratic Club 23, 40, 89, 92
Jamaican Ginger ("jake") 29
jazz 51, 53, 78, 85, 93, 108, 124, 138, 140, 146, 147
judges and justices 65, 116, 117, 119, 120, 121, 146

K

Kansas City Club 98, 101
Kling, Johnny 68, 147
Ku Klux Klan 60, 61, 112

L

Lazia, Johnny 25, 50, 73, 91, 95, 123, 124, 128, 143
Lewis, Sinclair 62, 82
Liberty Memorial 78, 95
liquor, bonded 20, 38, 42, 45, 101, 128
liquor concealment 25, 35, 38, 47, 113, 128

INDEX

liquor convictions 30, 34, 40, 41, 42, 46, 52, 56, 82, 89, 103, 107, 118, 120, 123, 124
liquor disposal 111, 128
liquor, distilled 20, 25, 26, 31, 35, 42, 45, 56, 112
liquor laws 17, 21, 32, 36, 37, 106, 119, 144, 146, 149
liquor, poison 20, 27, 29, 112
liquor, sources of bonded 20, 38, 42, 103, 128
liquor, synthetic 20, 28, 42, 43
liquor theft 23
liquor wholesalers 23

M

medicinal whiskey 20, 45
Morris, Milton 74, 142, 147

N

narcotics 45, 48, 57, 60, 65, 75, 88, 113
near-beer 23, 32, 34, 43, 98, 137
nightclubs 24, 43, 123, 138, 140, 142, 144, 147
North Side 23, 25, 27, 29, 30, 31, 35, 36, 44, 64, 65, 68, 74, 79, 80, 106, 116, 117, 124, 128, 138, 140, 142, 143

P

padlocks 42, 45, 50, 54, 65, 79, 85, 89, 92, 96, 107, 119, 124, 134, 136, 139, 143
Paris of the Plains 145
Parker, Charlie 146
Pendergast Distributing Company 23
Pendergast, James M. 131
Pendergast, Jim 134
Pendergast, Thomas J. 40, 49, 72, 73, 89, 102, 108, 131, 134, 145
Pendergast Wholesale Liquor Company 23, 25
police, criticism of 54, 61, 91, 104, 110, 114, 124
policemen, notable 111, 112, 113
Police Station No. 4 114
politicians 51, 89, 91, 97, 102, 104, 105, 107, 110, 119
pool halls 68, 96, 105, 134
prostitution 27, 60, 64, 65, 144, 146, 147
protection from prosecution 50, 52, 62, 68, 89, 97, 110, 122, 124

R

raids and cleanups 18, 28, 32, 34, 35, 37, 43, 46, 50, 51, 53, 56, 63, 66, 68, 70, 72, 76, 79, 83, 86, 89, 91, 92, 98, 104, 105, 107, 109, 111, 114, 121, 122, 123, 132, 138, 143
religious leaders 17, 59, 61, 66, 73, 82, 83, 110
repeal 43, 106, 131, 136, 140, 142, 144
Republican National Convention of 1928 95
Rieger, J. & Company 23, 90

Riverside Park racetrack 24, 72
Roosevelt, Franklin D. 131, 132
Runyon, Damon 88

S

saloons 17, 23, 32, 43, 44, 46, 64, 105, 110, 134, 136
Shawnee Indian Mission 50
slot machines 53, 60, 96, 125, 128
Society for Suppression of Commercialized Vice 59, 60, 64, 66, 77, 88
soft drink parlors 32, 42, 43, 46, 96, 105, 107, 108, 110, 119, 121, 126, 134
South Side 56, 75, 79, 101, 102, 120, 124, 139
South Side municipal court 114, 117
speakeasies, types of 43
Spencer, Nat 59, 149
Stanolax 28
stills 25, 27, 31, 35, 41, 56, 112
stockyards 21, 23, 41, 98, 126
sugar syndicate 30, 31, 143
suicides 54

T

Truman, Harry S. 51, 102, 107, 113

U

Union Station 70, 76, 87, 88, 126

V

Valot, Georges 144
Volstead Act 17, 18, 20, 21, 25, 30, 37, 92, 106, 119, 123, 128, 130

W

Waltower building 37
wartime prohibition 17, 18, 21, 22, 89, 128
Weissman, Solly 34, 73, 101
West Bottoms 28, 64, 72, 87, 105, 130, 133
wet block 134
Wilson, Woodrow 17
wine 31, 35, 37, 56, 80, 119, 120
Woman's Christian Temperance Union (WCTU) 18, 59, 63, 149

Y

Yokel Row 87, 90, 114

About the Author

John Simonson is the author of two other books published by The History Press: *Paris of the Plains: Kansas City from Doughboys to Expressways* (2010) and *Kansas City 1940: A Watershed Year* (2013). He lives in Kansas City, Missouri.

Visit us at
www.historypress.net